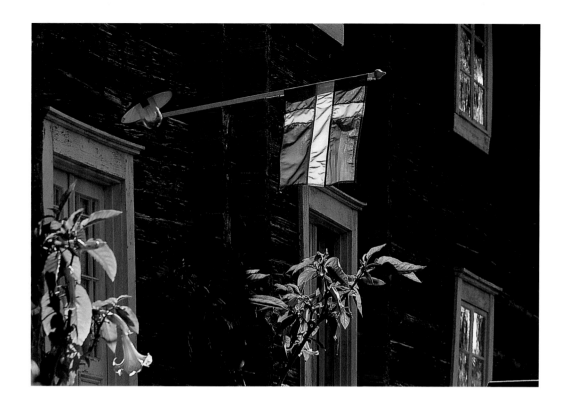

Journey through

SWEDEN

Photos by

Max Galli

Text by

Ulrike Ratay

Stürtz

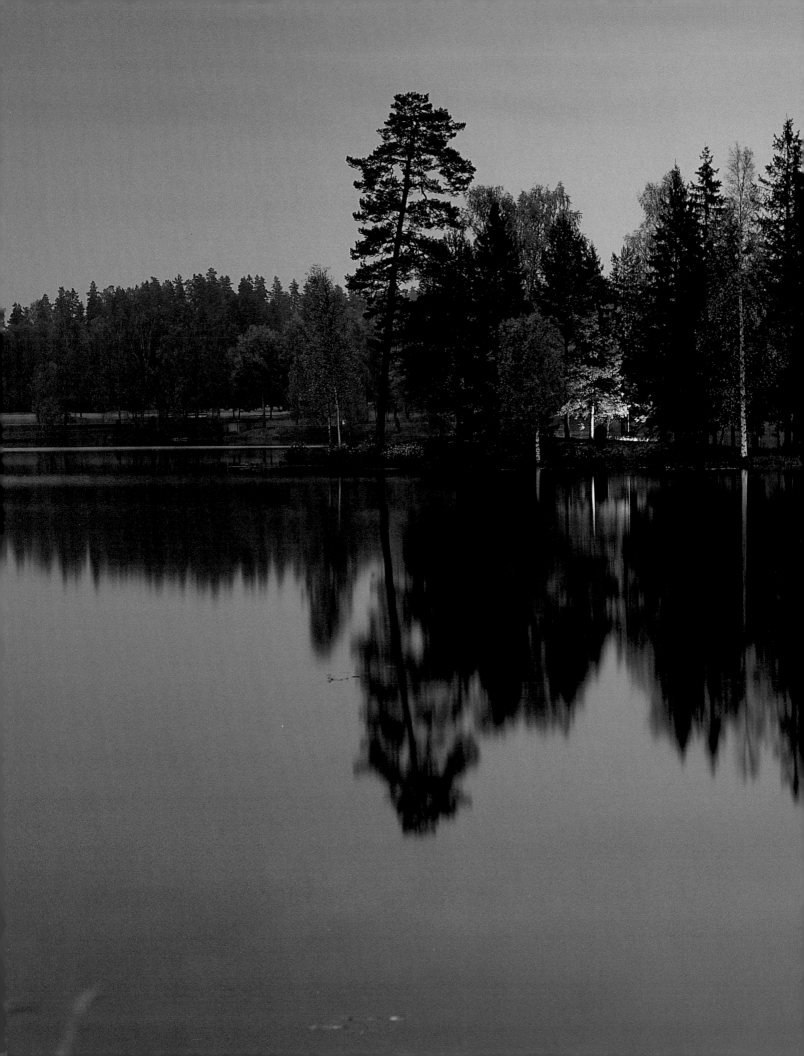

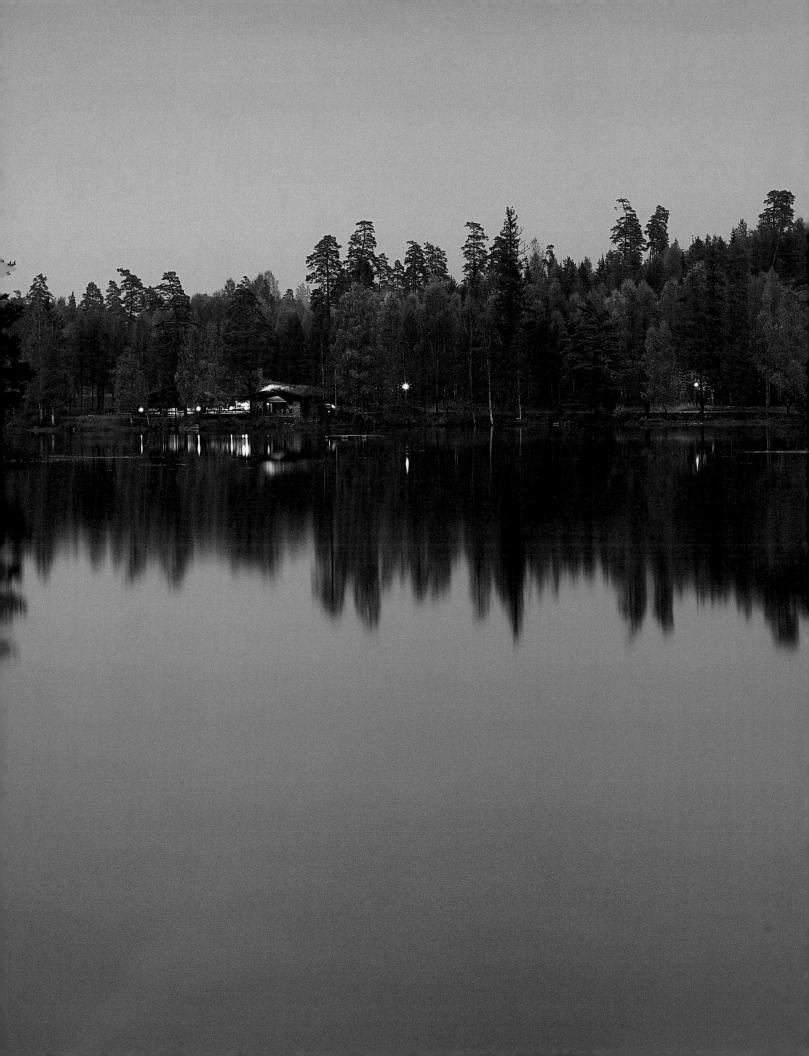

CONTENTS

Page 1:
The Swedish flag is very much part of the Swedish identity, found fluttering in the breeze on even the smallest of houses.

Previous page:
Hundreds of tiny lakes, such as Lake Höksjön, bathed here in the eveni...

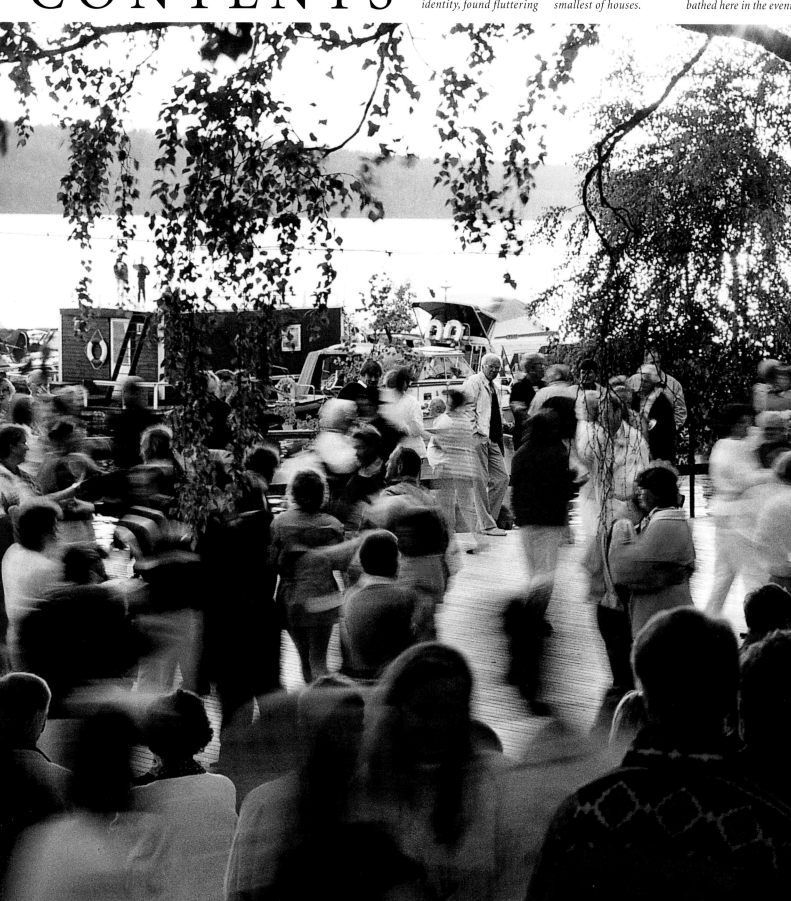

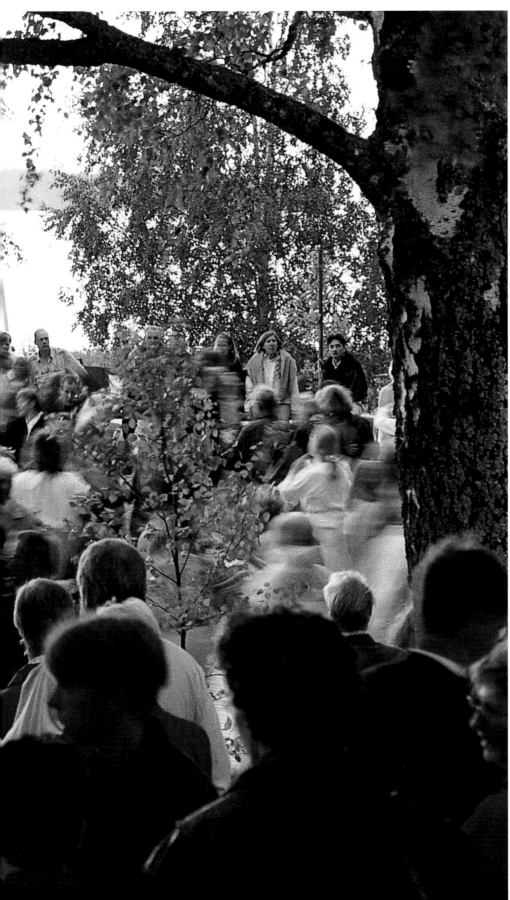

*ght, are the defining
ature of the largest
rovince in southern
weden, Småland.*

Below:
*The longest day of the
year, Midsummer's Eve
or the summer solstice,*
*is celebrated in style in
Leksand on Lake Siljan.
In fine weather people*
*dance outside under the
open sky all night long.*

Page 10/11:
*Looking across one of
Sweden's many expanses
of water to Stockholm's*
*old town island, Gamla
Stan, with its narrow
streets and imposing
facades.*

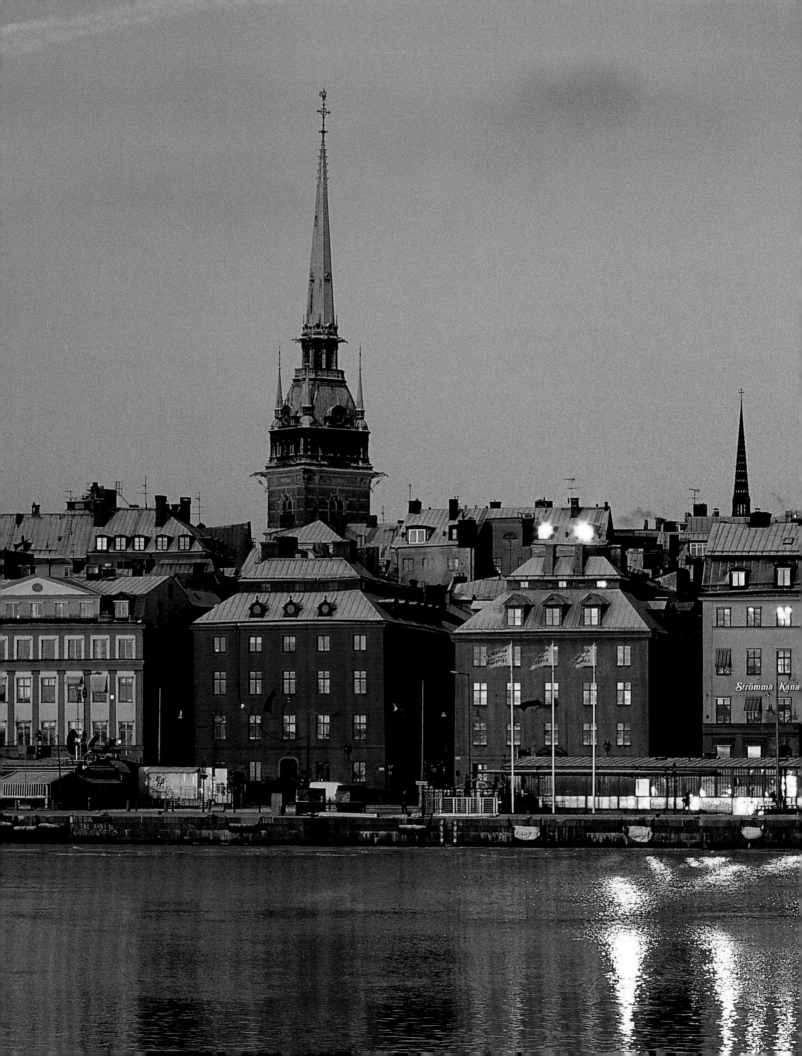

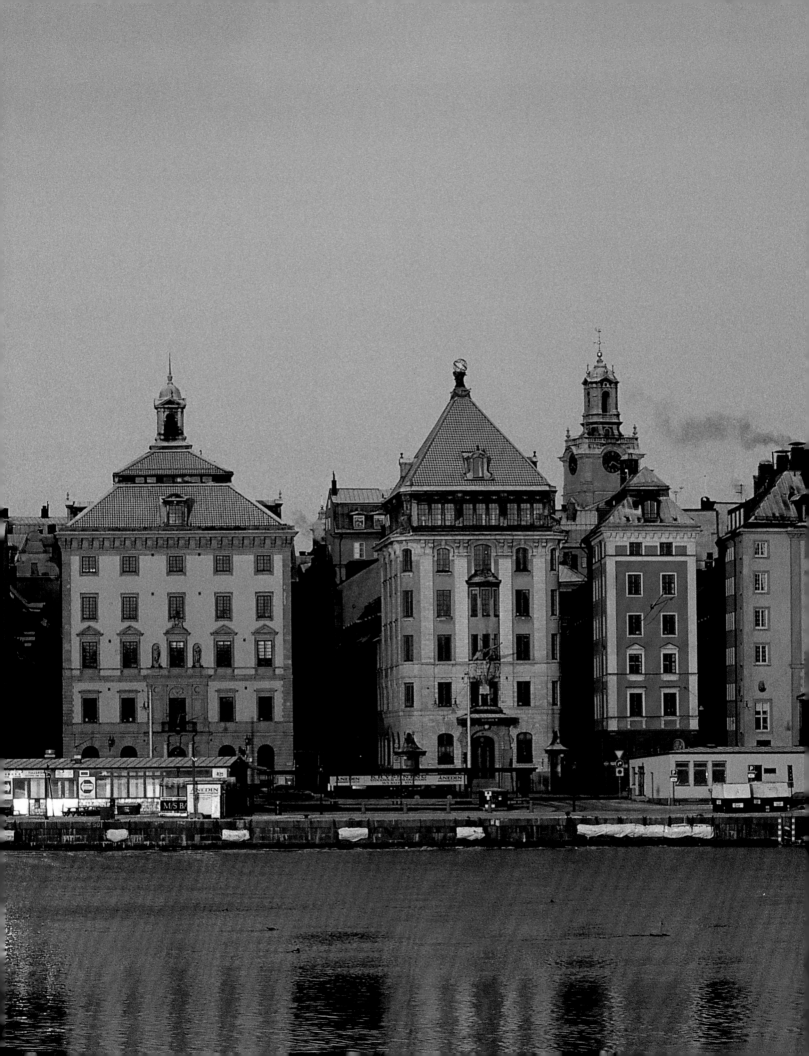

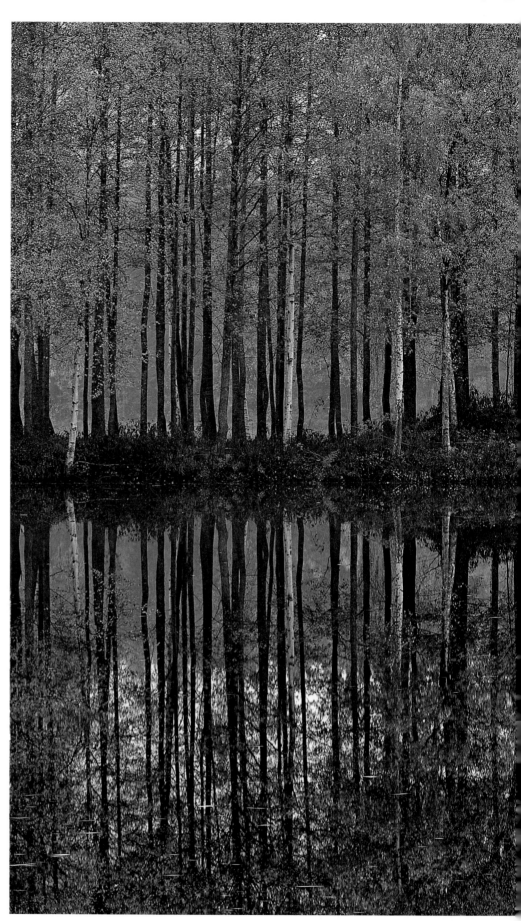

*Sweden isn't just
beautiful in the summer;
the softer colours of
autumn also effuse a
charm of their very own,
such as here in Rörvik
in Småland.*

I want to sing the praises of summer in Sweden to those of you who believe that up here nature is neither delightful nor beautiful.« Today Ernst Moritz Arndt, an early tourist to the country in 1804, wouldn't have any trouble convincing his travel adversaries; in our day and age it is common knowledge that the scenery in Sweden – summer or no summer – is absolutely breathtaking. There is almost no other nation in Europe where the countryside has remained as unspoilt as it is in Sweden, with its dark, dense forests, peaceful skerries, glittering lakes and the wild, snowy wastes of Lapland. Where in our minds the north is striking and sublime, raw and inhospitable, southern and central Sweden is pure, unadulterated Bullerby idyll, where happy Swedes lead a peacefully rural existence in red log cabins with white window frames. The coppery red of the houses here has become the trademark of romantic Sweden. The paint adorning the exteriors, »faluröd«, was once a waste product from the copper mine in Falun. Cheap and easy to come by, it contained copper vitriol, a strong preservative, providing Sweden's traditional wooden houses with ideal protection from the wind and weather. In colourful contrast, the local manor houses are usually painted yellow.

SWEDEN'S UNOFFICIAL
NATIONAL BEAST

When you think of Sweden, besides the usual green forests, red huts and blue sky dotted with white, fluffy clouds one other cliché might immediately spring to mind: the elk, Sweden's unofficial national animal. Elks are the »éminences grises« of the forest, primeval beasts with the heftiest torsos in the country. Weighing in at 400 kilos (almost

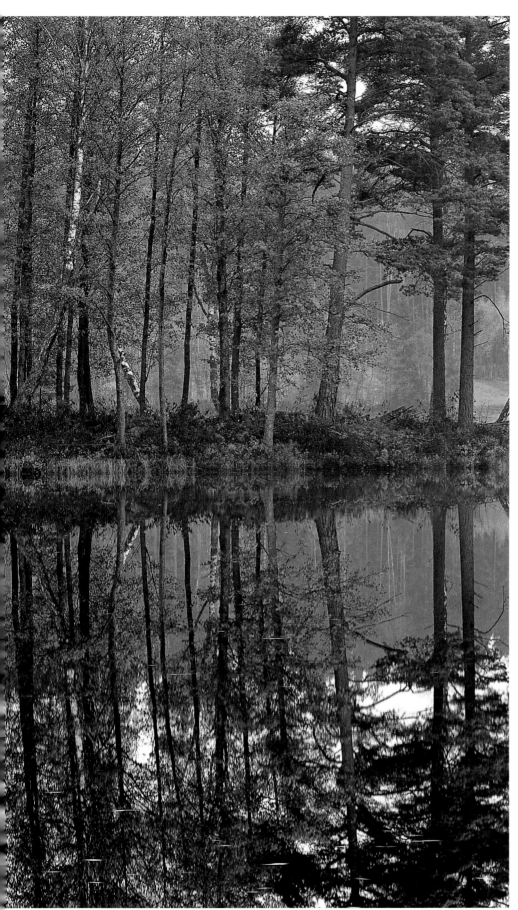

900 lbs) supported on extremely spindly legs, for the Swedes the elk is primarily a traffic hazard, with several thousands falling victim to road accidents each year – often at mortal risk to the unfortunate driver. Visitors to Sweden, however, totally in awe of this ungainly creature, pinch the road signs which warn of its presence; elk products, including dried droppings, do a roaring trade. Incidentally, Julius Caesar was familiar with the long-legged king of the forest but obviously not an expert on the subject, believing that they had neither ankles nor knees and that they slept standing up, leaning against a tree. According to Julius, the best way to hunt elks would thus be to saw down a tree at night and collect the felled beast the next morning. At a present rate of 100,000 animals shot per year, this would leave rather large gaps in Sweden's forests.

LOTS OF SPACE, NOT MANY PEOPLE

Bar the extreme south, the elk can be found almost everywhere within the 450,000 square kilometres (over 170,000 square miles) which constitute Sweden. By way of contrast, the distribution of the human populace is almost the exact opposite. With just 8.8 million denizens, the fourth-largest country in Europe is extremely sparsely inhabited. 86% of the population live in the third of the country south of the 61st degree of latitude, with only 14% in the north. Among them are the natives of the far north, the Sami or Lapps. Nowadays only 15,000 of what were originally 50,000 Sami still live in Sweden. The rest are spread out across Norway, Finland and Russia. The life of the Sami, the »Red Indians of the north«, has completely changed. Only c. 2,500 Sami still make a living from traditional reindeer herding; it is also no longer necessary for the entire family to accompany the animals into the mountains. Helicopters, motorised sleighs and walkie-talkies also make the job much easier.

Sweden is 1,574 kilometres (978 miles) long, approximately the distance from Hamburg to Rome, and 500 kilometres (310 miles) wide. It stretches across several climatic zones and encompasses four zones of vegetation – from fertile farmland in Skåne to arctic tundra in Lapland. Geographically, Sweden is divided up into 25 »landskap« or provincial landscapes which are historic re-

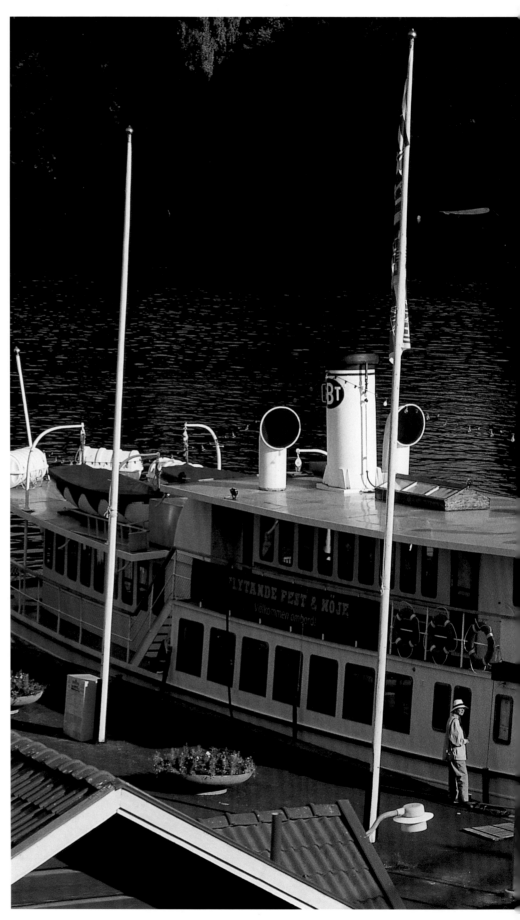

The Gustav Vasa chugs back and forth across the enormous Lake Siljan in Dalarna. Old customs and traditions have been lovingly upheld in the small villages dotted about the shore.

gions in their own right. They no longer perform any administrative function, yet for many they are part and parcel of their identity. People don't claim a particular »län« or administrative district as their homeland, but speak instead of coming from one of the ancient provinces, such as Dalsland or Skåne, for example. These 25 regions are distributed across the three major sections of Sweden, the south, centre and north – or Götaland, Svealand and Norrland, as the Swedes would say.

NOT AS COLD
AS YOU THINK

»When people in Germany think of Sweden, they think of Swedish punch, bitter cold, Ivar Kreuger, matchsticks, bitter cold, blondes and bitter cold. It's not actually that cold«, Kurt Tucholsky, the famous German writer, claims in his »Schloss Gripsholm«. Thanks to the Gulf Stream Sweden has a surprisingly mild climate, even if the enormous spread from north to south does mean that the various regions experience extreme differences in temperature. Where it can be warm and summery in the south in May, in the north the ice on the lakes is just beginning to melt. And as would be expected, winter in the north is long, dark and excessively snowy. By way of compensation those north of the Arctic Circle can enjoy the phenomenon of the midnight sun.

THE PERFECT CLIMATE FOR
SWEDISH INVENTORS

The long, dark winters might possibly explain why the Swedes are so inventive. What else is there to do during the cold season except sit at home and think?! A surprising number of patents have originated in Sweden, Alfred Nobel, the inventor of dynamite and the man who endowed the world-famous prizes, being notably prolific with 350 of his own. Anders Celsius introduced the centigrade temperature scale which Carl von

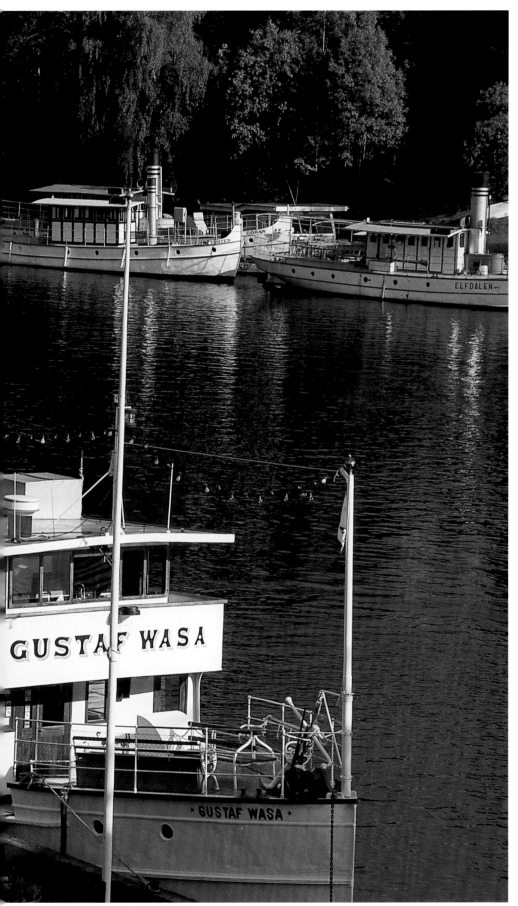

Linné (or Carolus Linnaeus) later modified to produce the system we use today. Linné himself, otherwise known as the »king of flowers«, also brought order to the botanical system of nomenclature, introducing a binomial designation of genus and species. The adjustable spanner was the idea of blacksmith and mechanical engineer Petter Johansson and Rune Elmqvist developed a pacemaker which could be implanted in the body. Håkan Lans made PCs more user-friendly by introducing the computer mouse, something many of us could no longer imagine doing without.

Sweden also has plenty of entrepreneurial spirit. The successful clothes chain Hennes och Mauritz (H & M), which markets top fashion at prices even teenagers can afford, is – you've guessed it – Swedish. As is the now (in)famous blue-and-yellow furniture store selling cheap Swedish fittings and furnishings you can (try to) cram into your car and put together at home. The first two letters of IKEA's name stand for its founder, Ingvar Kamprad, born in Agunnaryd, a tiny village in Småland. His great sales notion was not only to cut costs by having customers collect and assemble furniture themselves but also to print vast numbers of catalogues which were distributed free of charge. The catalogues depicted the items for sale in a credible domestic setting, saving clients the effort of trying to imagine how their purchases would look once arranged in situ. At the same time Kamprad's catalogued furnishing suggestions influenced the interior design of an entire nation. By 1989 IKEA had 90 stores in 20 countries. If you ever make it to one of the Swedish originals, don't try looking for that familiar blue-and-yellow exterior; in Sweden, IKEAs are red and white.

A BIG HISTORY OF A SMALL PEOPLE

Even if Sweden hasn't got »pyramids like Egypt, marble temples, catacombs and sunken cities like Italy, vineyards like France, knight's castles like Germany and Alps like Switzerland«, to paraphrase Alf Henrikson, you'd be wrong to think it's all dark forest, sapphire lakes and majestic elks. Dotted about the spectacular countryside traces of Sweden's significant history abound, symbols of long periods of economic and political supremacy. Medieval churches – of which

there are almost a hundred on the island of Gotland alone – castles, palaces and manor houses bear eloquent witness to Sweden's turbulent and interesting historical development. Prehistoric and early historical sites include burial mounds and boat-shaped stone formations, such as the one at Ales Stenar near Kåseberga on the south coast of Skåne, possibly the most impressive remnant of a much older tradition when graves marked the journey of the deceased to the kingdom of the dead. Excavated ancient weapons and particularly Sweden's mysterious rock carvings (hällristningar) still have scholars puzzling over the social order and pagan gods of earlier civilisations.

VIKINGS ON THE RAMPAGE

Tacitus was the first to mention the far north in his »Germania« from 98 BC, where he writes of a number of tribes ruled by a chieftain or king. By the early Middle Ages, Europe was firmly in the hands of tribes such as these: the Vikings. Social and/or climatic change had prompted the Scandinavian adventurers to abandon the north; they pillaged, plundered and aggressively bartered their way south to Byzantium. The first reliable record of their violent deeds is the raid on Lindisfarne monastery off the northeast coast of England in 793. By the first half of the 11th century King Canute had built up an empire which spanned the North Sea, engulfing Denmark, Norway and large sections of England. At this time the Swedes were still heathens, despite the efforts of Ansgar, a monk sent to Birka in 830 by Emperor Louis the Pious to try and convert the pagan populace. He was unsuccessful; the Germanic gods proved stronger. It wasn't until 1120 that a fixed church order was established in Sweden.

The high Middle Ages was marked by rapid expansion and development of the towns and the bourgeoisie, by colonisation of vast areas of forest and by flourishing trade with the Hanseatic League. It was also darkened by conflict between the nobility and the king. At the close of the 14th century three Scandinavian nations, Denmark, Sweden and Norway, joined forces to form the Kalmar Union. Queen Margrethe, already ruler of Denmark and Norway, was now also queen of Sweden. Other foreign potentates followed, with prolonged power struggles between various factions of the aristocracy placing a

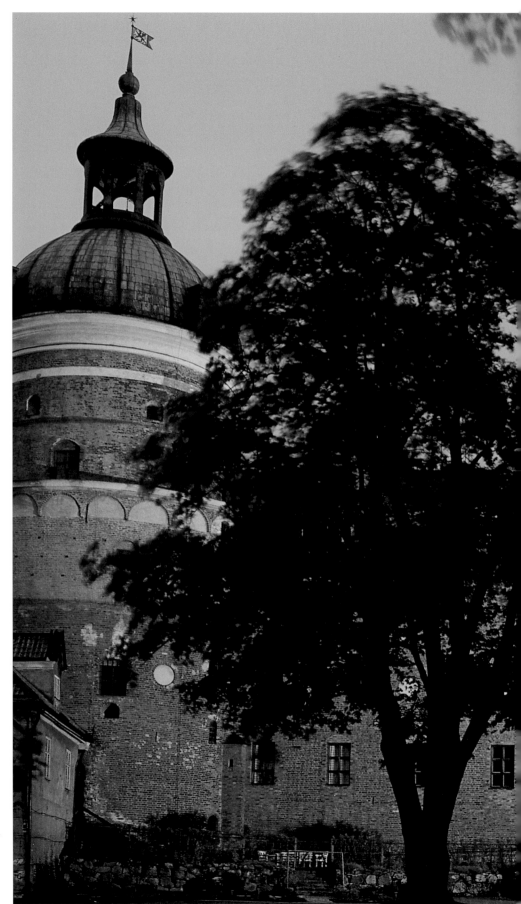

16

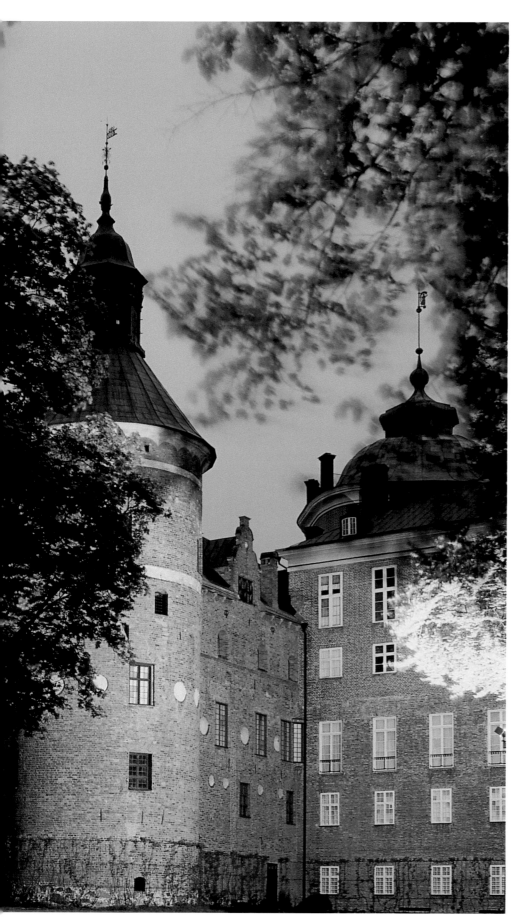

succession of Danes and Swedes on the throne. Finally, the cruel Danish king Christian II came to power and attempted to crush Swedish resistance once and for all in the Stockholm Bloodbath of 1520. One defiant nobleman refused to submit to the new oppressor: enter Gustav Vasa.

THE LEGENDARY GUSTAV ERIKSSON VASA

Beating a hasty retreat from the wrath of the Danes Vasa tried to persuade the people in the Dalarna region of Mora to rebel – with little success. He then fled on skis to the Norwegian border. Soon after his departure the peasants in Dalarna had a change of heart and sent their best skiers hurrying after Vasa. They managed to catch up with him 89 kilometres (55 miles) away in Sälen. With an army behind him, Vasa led a revolution against the Danes and in 1523 was crowned king in Stockholm. In celebration of Vasa's victory, each year at the beginning of March the »Vasaloppet« is held in Sweden, a grand sporting event in which 12,000 skiers race from Mora to Sälen, fortified along the way by »blåbärsoppa« (blueberry soup).

Vasa broke with Rome and reformed the Swedish church. This considerably replenished the state coffers, as land and property belonging to the Catholic church now belonged to the Swedish nation. The Lutheran church was made the state church of Sweden; it was only in 1951 that freedom of worship was granted.

POWER POLITICS AND THE GUSTAVIAN STYLE

Although succession to the throne was hereditary from Vasa onwards, skirmishes for power among the various heirs persisted, as did the fight for sovereignty of the Baltic. During the reign of Gustav II Adolf Sweden finally reached its goal, becoming the definitive power in northern and central Europe. During the Thirty Years' War Sweden had victorious armies stationed in Poland, Russia, Germany, Austria and on the Baltic.

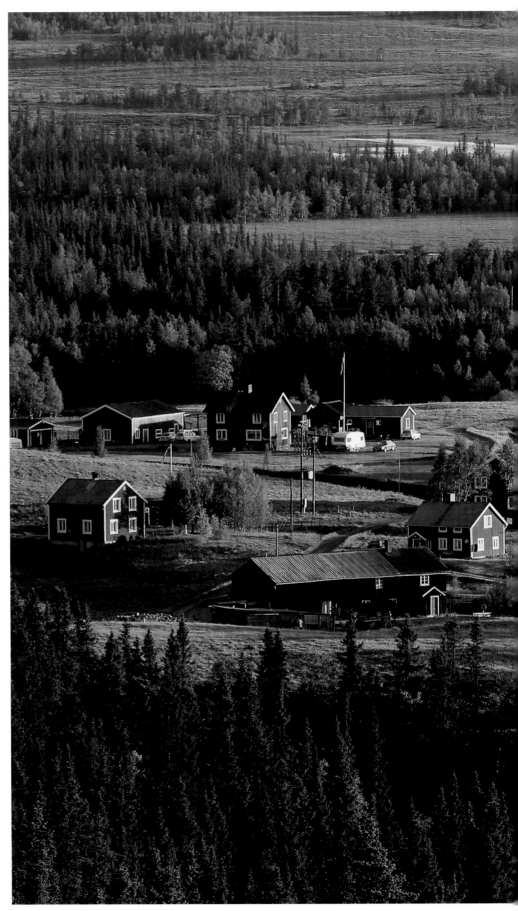

Handöl is a typical hamlet of red log cabins in Jämtland, the largest province in central Sweden, which has many lakes, rivers and mountains.

Under Queen Christina, an unusual character who ruled Sweden for 22 years only to then abandon politics and become a devout Catholic convert, the country gained land through the signing of various peace agreements. King Karl X conquered what was originally Danish land by marching across the frozen Great Belt towards Copenhagen in 1658. Sweden's luck didn't last, however; Karl XII's crusade against Russia marked the beginning of the end of the great period of domination. Subsequent kings found their sphere of influence increasingly restricted in favour of a strong parliament of the Estates.

Although Sweden's role in foreign politics became increasingly insignificant, internally the country boomed, with economy, science and the arts blossoming during the 18th century. This was the age of Anders Celsius and Carolus Linnaeus. During the reign of Gustav III, a great advocate of the arts, culture in Sweden peaked in the songs of Carl Michael Bellmann, the Gustavian style and the rise of opera and the theatre. In 1792 Gustav III was murdered at a masked ball, a deed which failed to bring about the intended downfall of the monarchy. In 1810 the Riksdag even elected a Frenchman and one-time marshal to Napoleon to the throne, Jean-Baptise Bernadotte, as the Swedish royal family was unable to produce an heir of their own.

SWEDEN ENTERS THE MODERN AGE – THE DREAM OF THE WELFARE STATE

In the wake of an explosion of the population in the 19th century there were several waves of emigration. At the same time the industrial revolution hit Sweden and government by the Estates was replaced by a two-house parliament. At the dawn of the

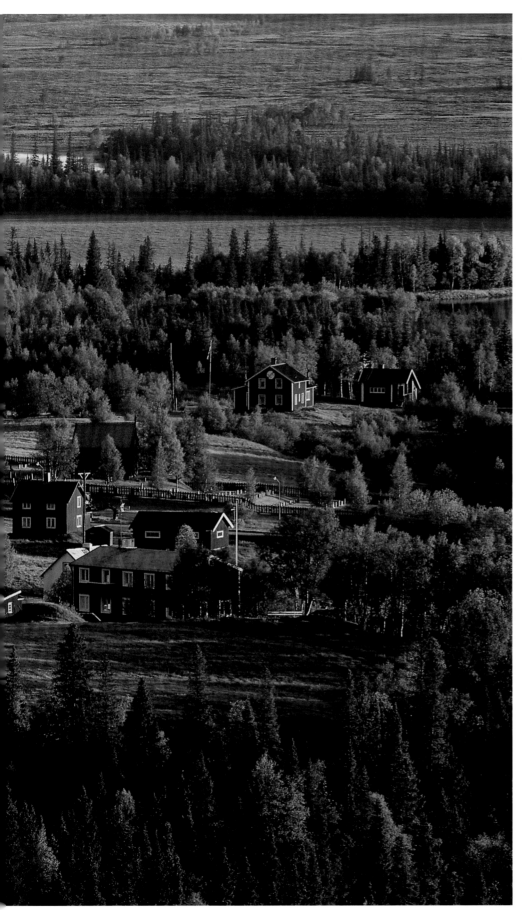

20th century universal suffrage was introduced. Surviving both world wars by remaining neutral, in 1940 the social democratic government began working to realise the Swedish dream of »folkhem« or a »home for the people«, where everyone could exist without material worries, regardless of what they did or earned. From the cradle to the grave people were to be looked after by the state in the much extolled »Swedish model«.

Lulled into a false sense of security after 200 years of peace, in 1986 the liberal Swedish welfare state was shocked by a brutal murder. On 28 February at 11.21 pm head of government Olof Palme was gunned down outside a cinema in Stockholm. Wild speculation as to the perpetrators followed, suspicion being heaped in turn onto a conspiracy group acting for the Swedish armaments industry, Israelis, Kurds, the CIA and right-wing members of the Swedish police, as the prime suspect, Christer Pettersson, although initially arrested, was later acquitted and released. Decades later the crime is still an old chestnut, regurgitated from time to time by Swedish journalists pursuing an endless tale of politics, police and blunders in the search for the killer.

Despite the murder of Olof Palme, belief in the »Swedish model« remained unshaken. Up until the beginning of the 1990s the housing subsidies, pensions, national health system, educational reform and other benefits pertinent to the welfare state were continually nurtured until reality hit Sweden hard with deficits in tax income, massive increases in welfare payments and high levels of unemployment. Despite the inevitable cuts which followed, the system managed to avoid total collapse.

The Sweden of the 20th century wouldn't be complete without its royal family, although they are not really the ideal accessoire to the modern welfare state, where everyone is supposedly equal, nor to the social democratic government, in power throughout much of the 20th century. Yet even though Sweden's nominal head of state, Karl XVI Gustav, who ascended to the throne in 1973, today has more of a representative function than a political one (this being left to parliament), the royal family remains extremely popular; the current queen (since 1976) is a German who, perhaps echoing the sentiments of the »Swedish model«, has kept her bourgeois name, Sylvia Sommerlath.

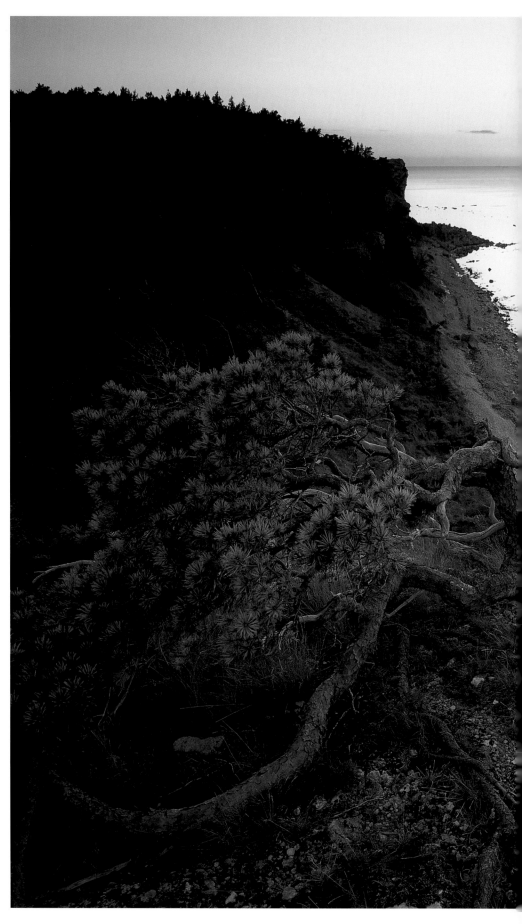

The coast at Lickershamn, a tiny harbour and fishing village on the island of Gotland, droops steeply down to the sea. This is where »raukar«, fantastic pillars of fossil reef, rise up out of the water.

TYPICALLY SWEDISH

Sweden is often a contradiction in terms; social democracy exists alongside a constitutional monarchy, a fanatical love of nature and of the simple country life sharply contrasts with a strong belief in the advance of technology. How else can you explain that the Swedes are both avid champions of frugal summers in country cabins – where the mod cons in the sanitation department usually consist of nothing more than an outside privy and running cold water – and also the most prolific users of computers, the internet and mobile phones? Or take alcohol, for example. Even after the Swedes joined the European Union in 1995 they clung to their splendid isolation with regard to licensing laws. Booze is still only sold in special state shops, more chemist's than off-licence, known as »Systembolaget« or »Systemet«; these are closed on Saturdays and Sundays. Astronomical taxes make wine, beer and spirits almost impossible to afford, yet there are still long queues for bottles of plonk, with the Swedes' alcohol consumption, particularly at the weekends, no lower than that of their fellow Europeans.

»ALLEMANSRÄTTEN« – AN ANCIENT SWEDISH RIGHT

Besides its celebrated scenery, what else makes Sweden so special and endearing? What makes Sweden so Swedish? It's definitely not the Swedish blonde, a cliché which is long outdated. It's the little things which the Swedes are so proud of and which can't be found anywhere else, like the »allemansrätten«, for example. This form of common law is an ancient Swedish right which is absolutely unique. It states that everybody has the right of access to any part of the countryside, even if an expanse of forest or a lakeside shore is private property. This doesn't mean that you can set up camp among the herbaceous borders in someone's front garden, of course; a certain degree of common sense when exercising the Swedish country code is required. Prospective campers are expected to ask permission when erecting tents near houses, to only light fires in safe places and to behave responsibly with regard to their natural surroundings.

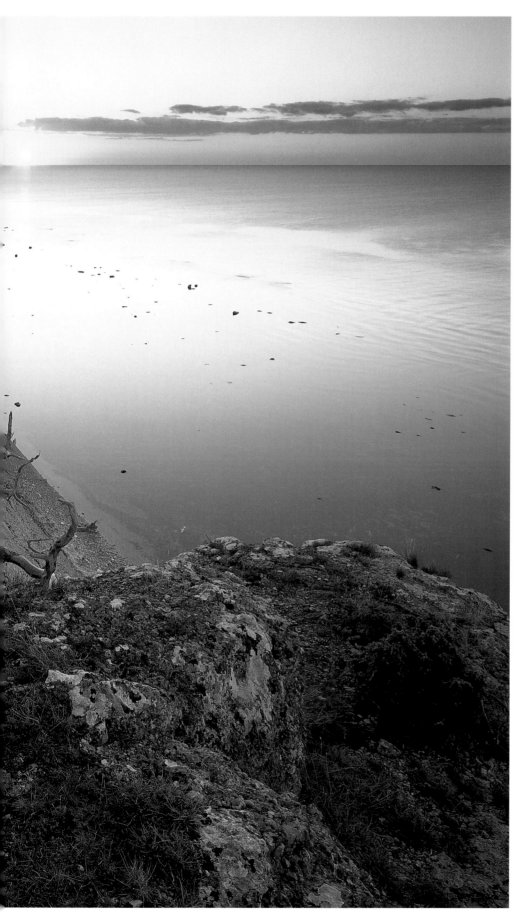

The Swedish language also has its quirks and peculiarities. Intonation and pronunciation are very different from that of the other Germanic tongues, as Tucholsky notes in »Schloss Gripsholm«: »The Swedish language is further back in the mouth and they sing so beautifully when speaking...« In Sweden the familiar form of address is still common practice, although there have recently been moves to make more frequent use of the more formal »ni« (the equivalent of »vous« in French or »Sie« in German). One typically Swedish word is »lagom«, which means something along the lines of »just right« or »fine«. »Lagom« is a word which is neither positive or negative and can be used in all situations. There's another Swedish word which is even more important: »tack«. »Thanks« and its various permutations are particularly important in any dealings with Swedes. Visitors should take great care not to omit the omnipresent »tack« where it could feasibly be used. In Sweden you thank people for just about everything. You give thanks for a meal (tack för maten), for a social gathering (tack för sällskapet), for attentiveness or a gift and when you've borrowed something from someone (tack för lånet). And if you ask someone to do something for you, you thank them in advance. To do as the Swedes do, it's better to use »tack« once too often than not enough.

And while we're on the subject of social etiquette, if you ever visit a Swedish home be sure to take off your shoes before you enter. Even if the custom is probably a flashback to life in the country, where muddy clogs were removed at the door, or in deference to the fact that many Swedish houses and flats have light floor coverings to counteract the long, dark winters, it's a nice idea to observe the code. Do check your socks for holes first, though...

Page 22/23:
Sweden's third national colour could almost be the coppery red of its log cabins. This farmhouse near Brohult in Småland is painted in the traditional »falunröd« with the window and door frames in white.

Page 24/25:
The calm of evening settles over Birger Jarls Torg on the island of Riddarholmen, part of Old Stockholm. Here 15th-century remains of the city walls encircle magnificent noble palaces, the old government building and several courts of law.

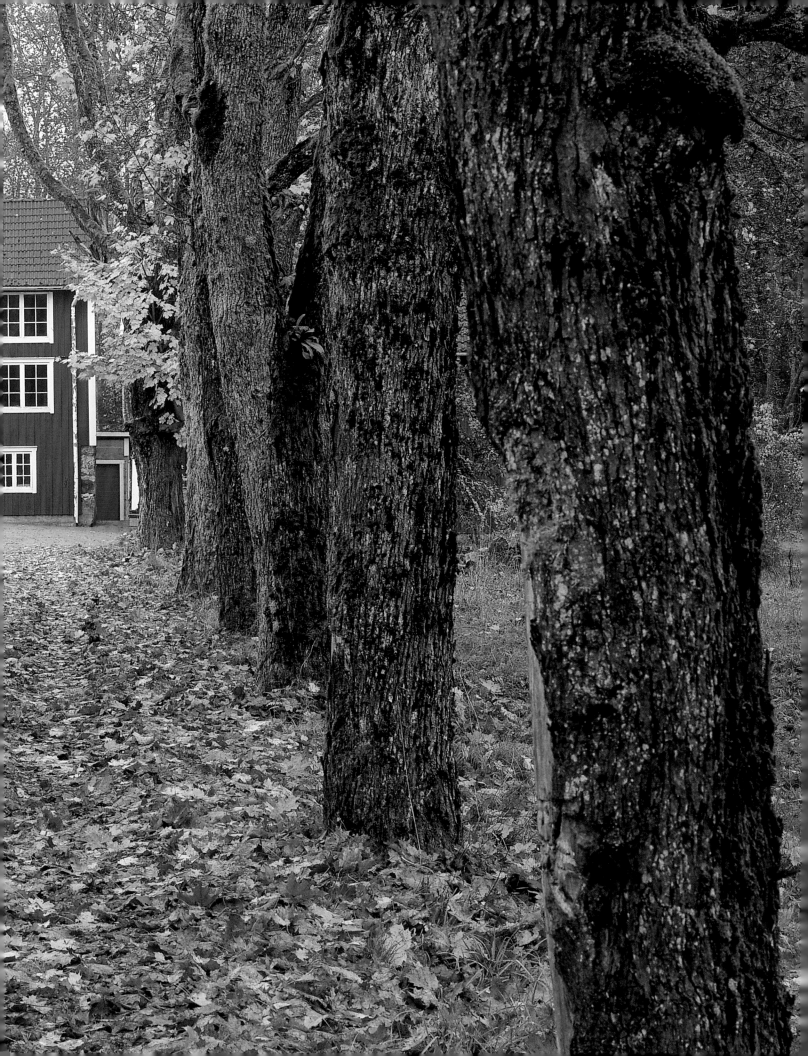

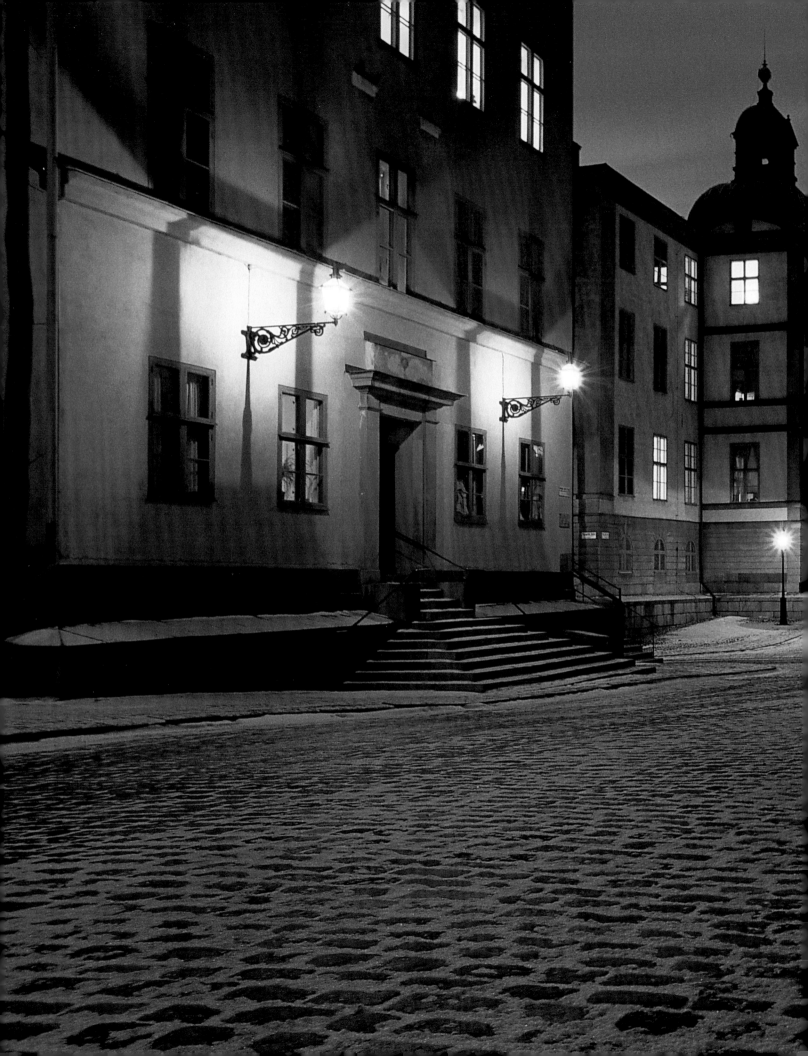

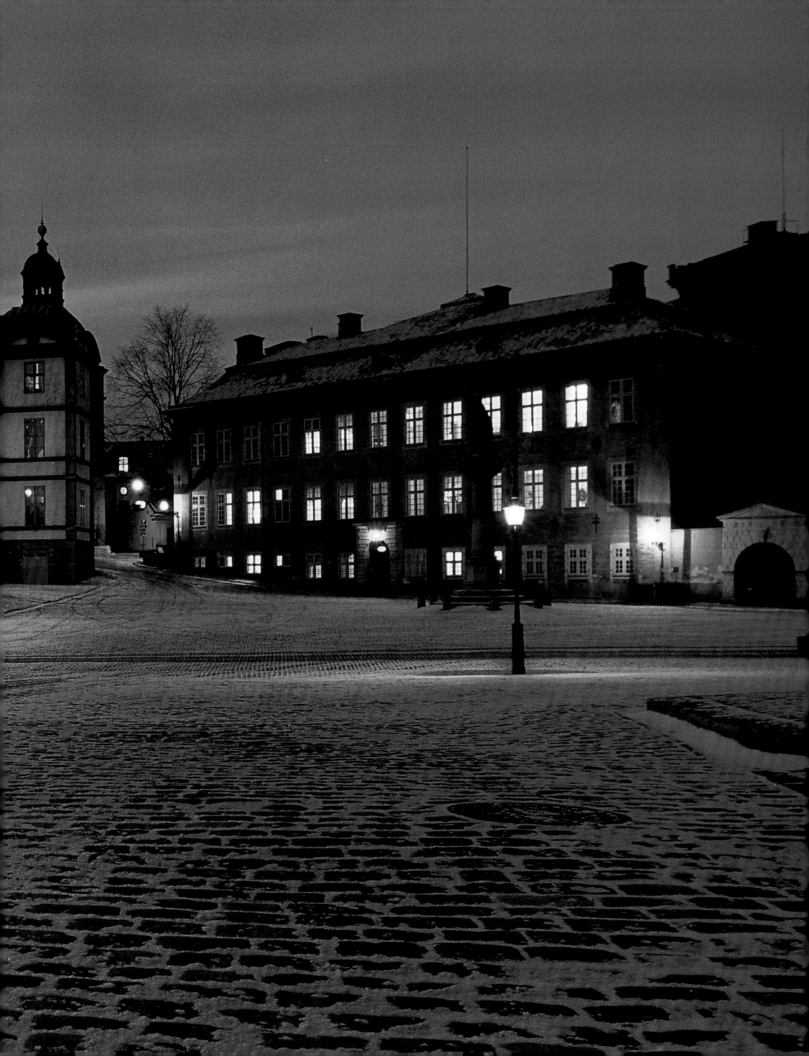

SOUTHERN SWEDEN

Southern Sweden, also known as Götaland (the land of the Goths), comprises the southernmost third of Sweden and the two islands of Öland and Gotland. Here in Skåne is where little boy Nils Holgersson set off on his journey on the back of a goose. From the sky the land below looked like »square upon square«, like »a great patchwork quilt«. The fields Nils saw still characterise Sweden's »granary«, which produces one third of the country's total agricultural yield. The south is also home to the third-largest city in Sweden and bridgehead to Europe, Malmö on the Öresund opposite Copenhagen. Northeast of Skåne is the »landskap« of Blekinge; if Skåne is Sweden's granary, Blekinge with its many fruit plantations is its orchard. Despite the name, Småland (literally: »little country«) is southern Sweden's largest province. Surrounded by water, with the Baltic and off-shore Öland to the east and the enormous lakes Vänern and Vättern to the northwest, Småland has breathtaking scenery and also a thriving glass industry, the area between Växjö and Nybro being known as the glass kingdom of Sweden.

On the island of Gotland, which has a landscape of its very own, august churches mirror the turbulent history of the island which only fell to Sweden just over 300 years ago. Travelling north on the mainland you reach the province of Östergotland, a rather flat region similar to Småland squeezed in between the Baltic and Lake Vättern.

Back on the west coast Halland carries on north from Skåne on the Kattegat. With its coastal resorts of Varberg, Falkenberg and Halmstad and many other seaside towns boasting sandy beaches, Halland and the neighbouring Bohuslän make up the Swedish riviera on the west coast of the Kattegat and Skagerrak. Bohuslän, named after the majestic Bohus Fortress, stretches up to the Norwegian border and contains Sweden's second-largest city Gothenburg, making it a hot contender with Stockholm for business and popularity. Inland, southern Sweden spills into Dalsland with its unspoilt forests and lakes. Västergötland lies east of the two coastal provinces Halland and Bohuslän, sandwiched between lakes Vänern and Vättern, where an abundance of tumuli and ancient burial sites from the Bronze Age affirm early settlement in the region.

Rolling hills, vibrant fields of rape, half-timbered cottages in tiny villages and lush avenues of trees are typical of the Skåne region, the granary of southern Sweden. Skåne was part of Denmark until 1658 and the scenery is still very reminiscent of its southern neighbour.

GRANARY, GLASS KINGDOM AND SWEDISH RIVIERA

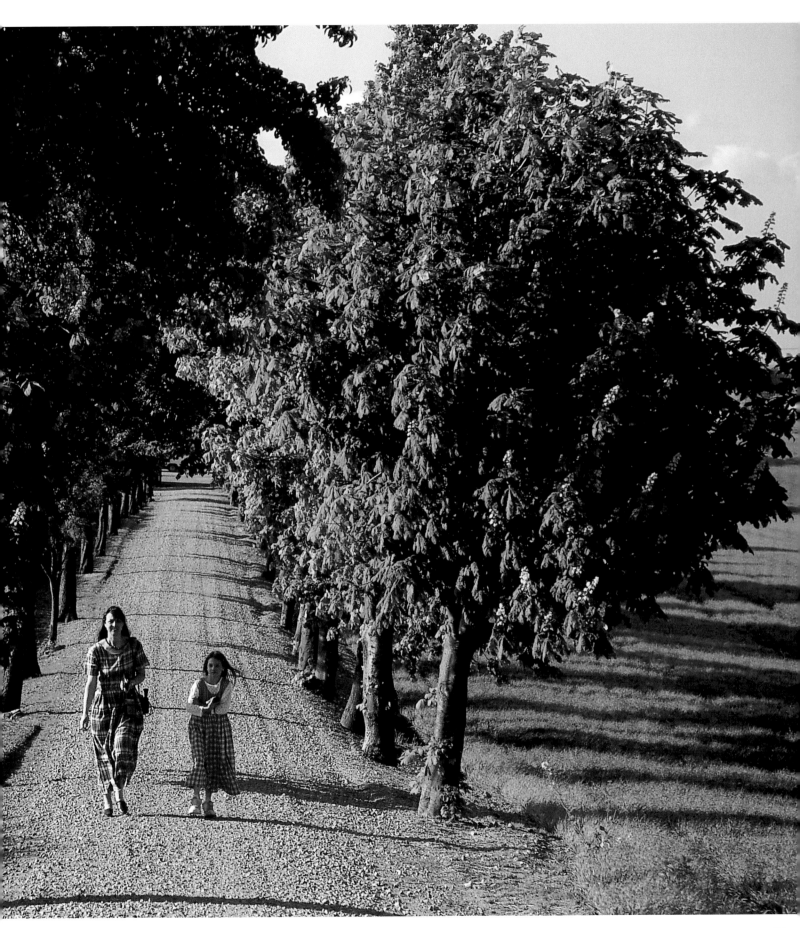

27

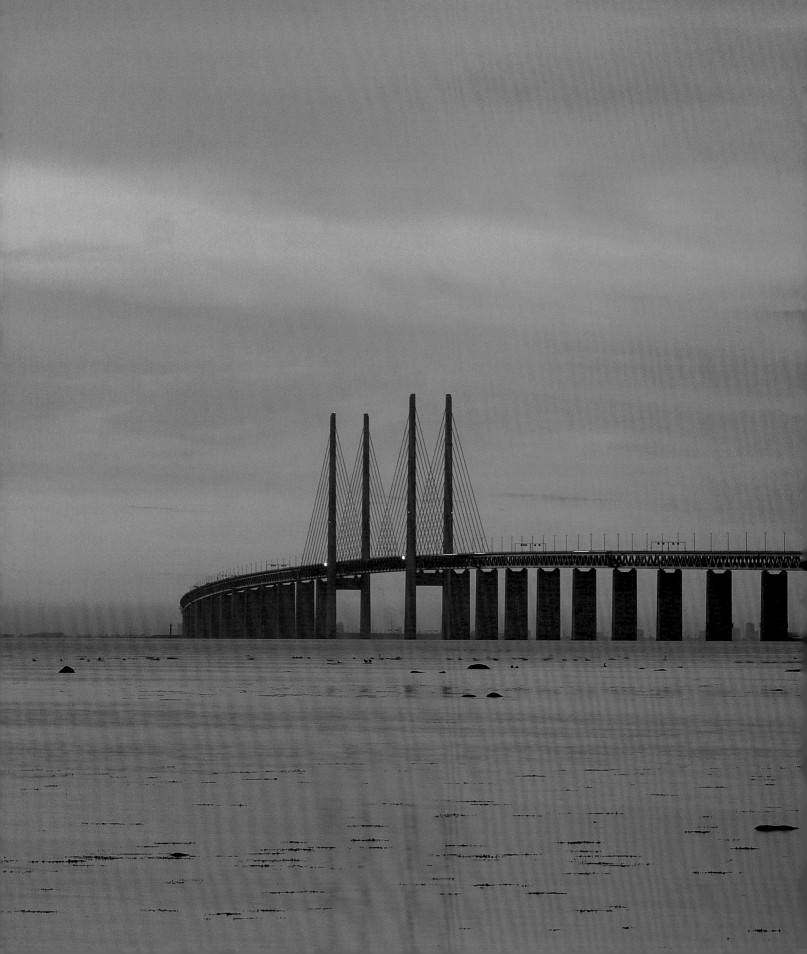

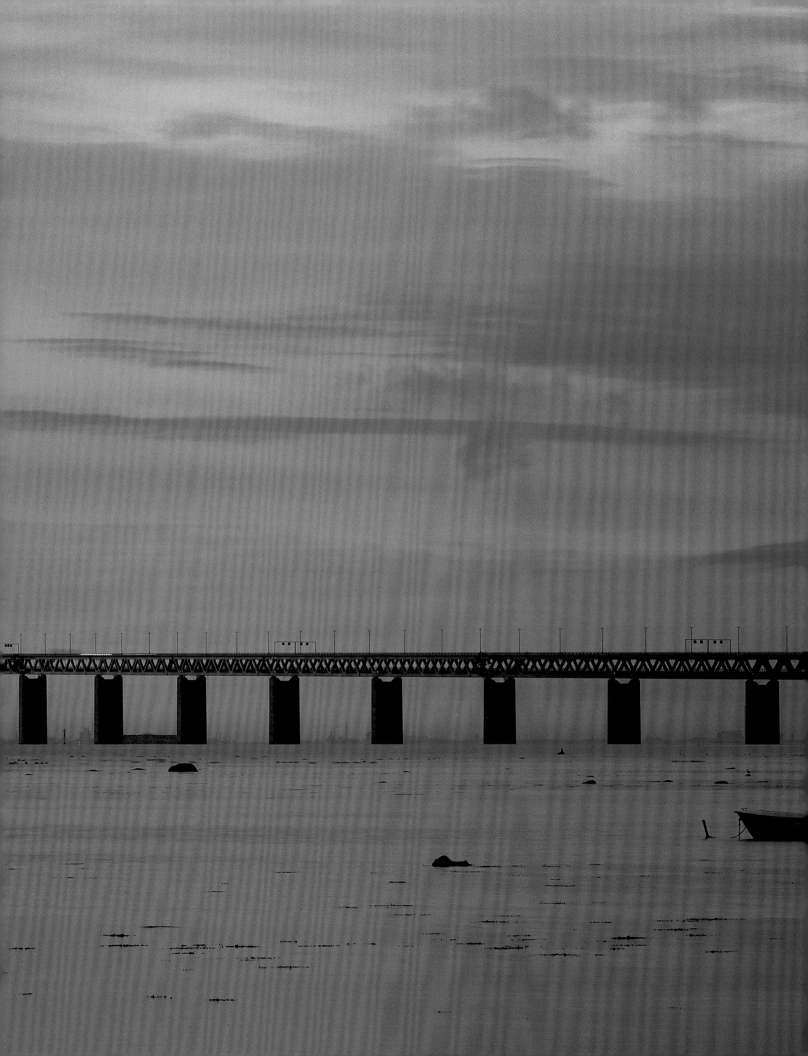

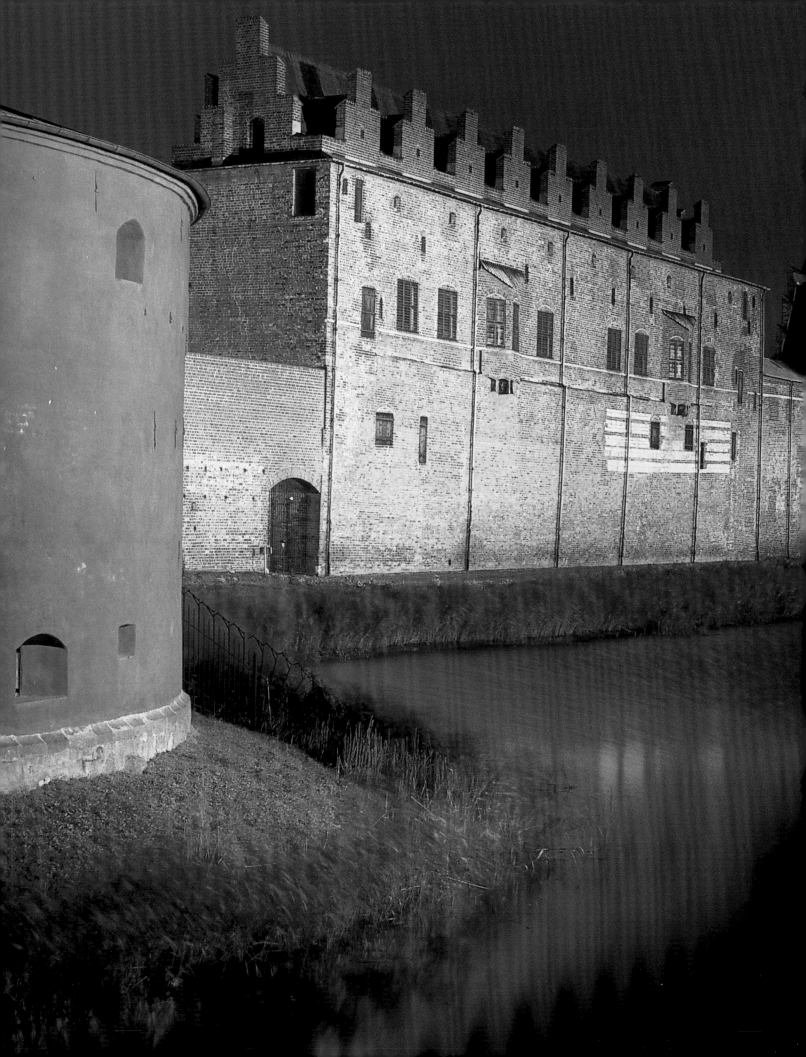

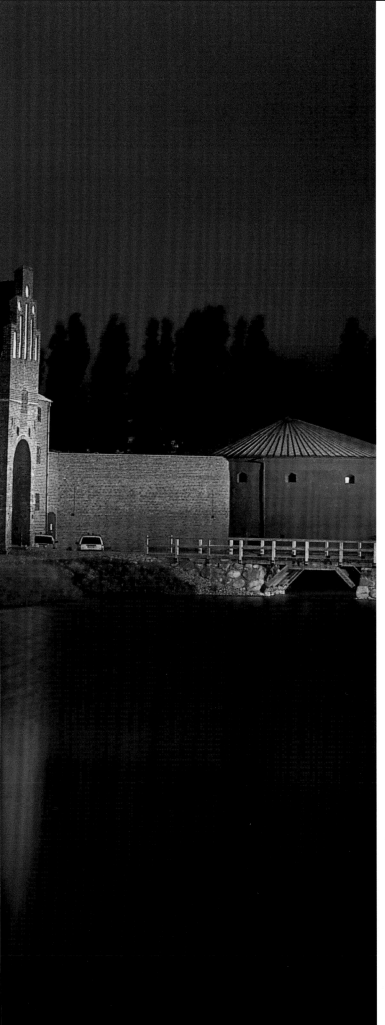

Page 28/29:
Sweden's millennium bridge is the impressive construction spanning the Öresund between Copenhagen and Malmö, completed in 2000. The longest cable-stayed bridge in the world makes Malmö Sweden's bridgehead to Europe.

Below:
The town hall on Stortorg in Malmö was erected in 1546 and much altered in subsequent years. It was rebuilt in the Dutch Renaissance style in 1864.

Bottom:
The Stortorg or great market in Malmö with its historic buildings is one of the largest city squares in Northern Europe. It was laid out in 1530 when the smaller neighbouring square could no longer cope with the boom in trade.

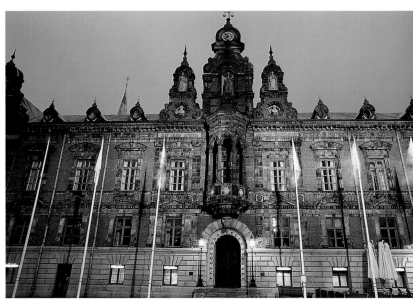

Left:
With its turbulent history behind it, the castle in Malmö now houses a number of museums. Erich of Pomerania first constructed a stronghold on this site in 1434 which Christian III replaced with a moated palace. Witch trials were held here during the 16th century and for many years Malmöhus Slott was a prison before being used for more peaceful pursuits in the recent past.

31

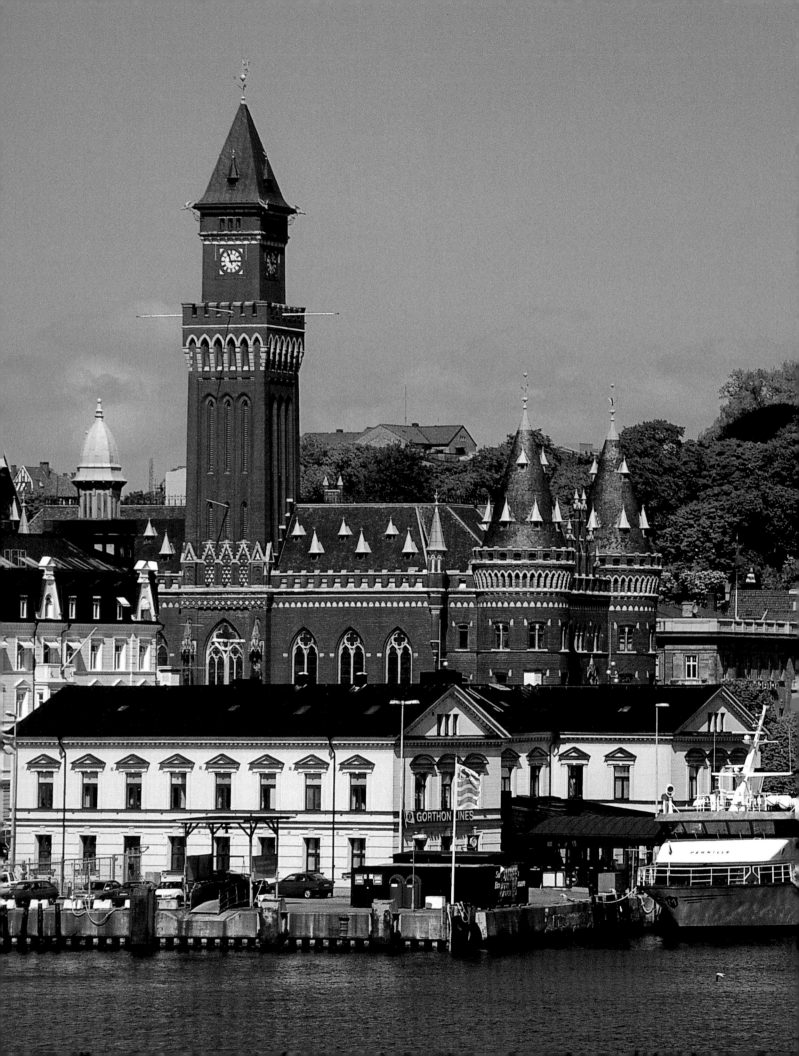

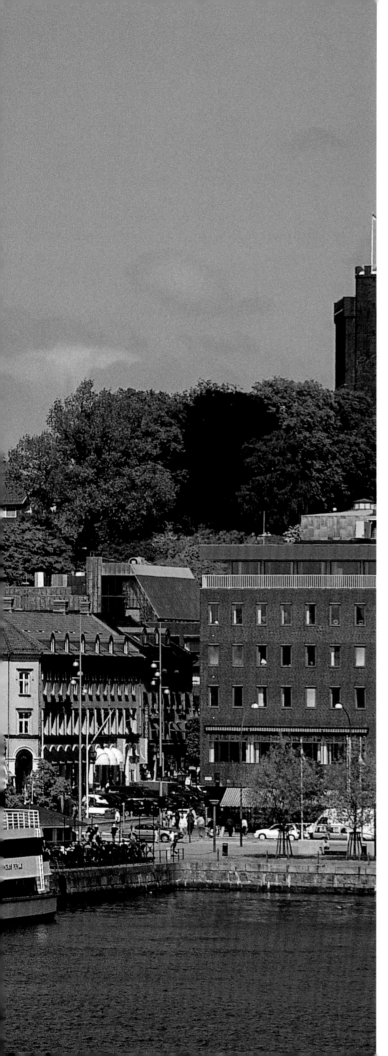

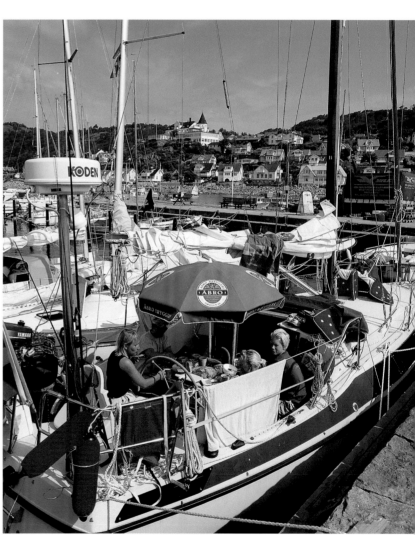

Above:
The yachting harbour at Mölle is always well frequented in the summer. The old fishing village was a famous seaside resort in the 19th century. It clings to the south-west flank of the Kullen peninsula, 20 kilometres (12 miles) from Helsingborg.

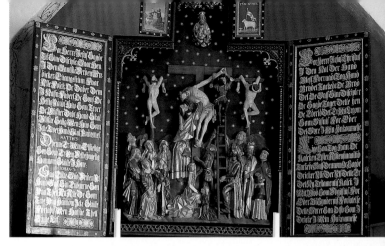

Right:
The altar in the church at the old Bosjö Monastery in Skåne depicts the Crucifixion.

Below:
Bosjö Monastery is on a peninsula – once a proper island – jutting out into Lake Ringsjö. The monastery was founded in 1080 by Benedictine nuns and fell to the crown during the Reformation.

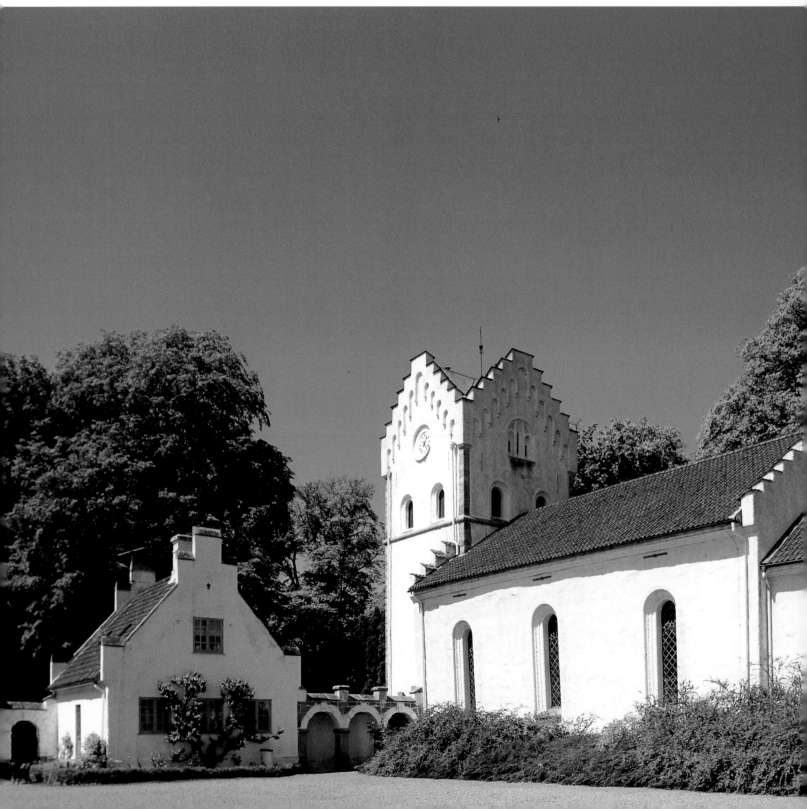

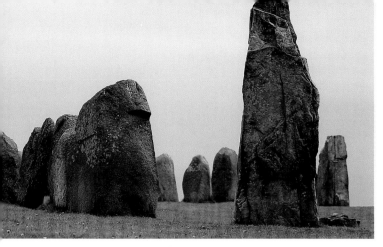

Left:
*Ales Stenar near Kåse-
berga is the largest stone
circle in Scandinavia.
Built in the shape of a
ship, it measures 67 me-
tres (220 feet) in length
and 20 metres (65 feet)*
*in width. It is thought
that Vikings erected the
58 granite monoliths,
some of them over six
feet tall. The exact func-
tion of this impressive
historical site remains a
mystery.*

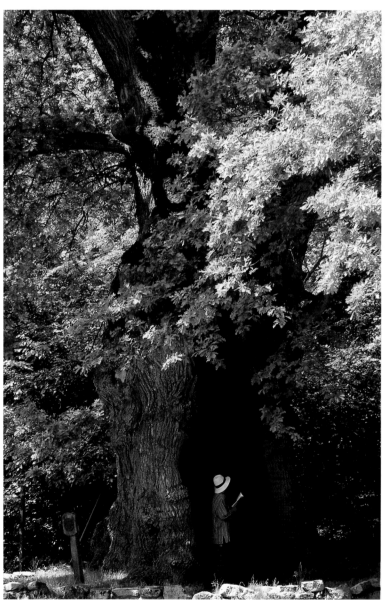

Above:
*Bosjö Monastery on
Lake Ringsjö is
surrounded by beautiful
parkland which contains
this majestic
1,000-year-old oak.*

Right:
The old university town
of Lund is one of
southern Sweden's
cultural centres –
not least thanks to its
many bookshops.

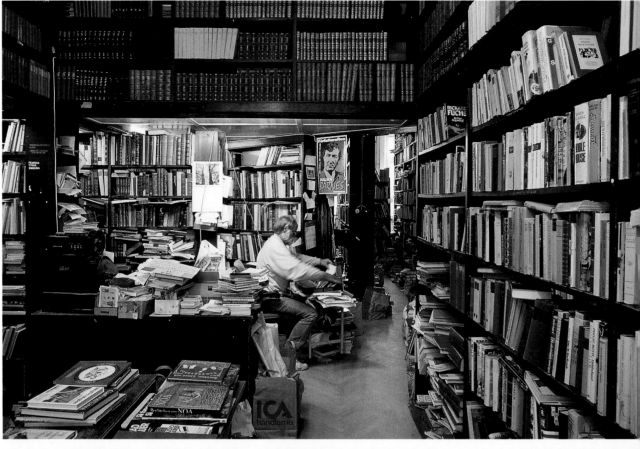

Below:
The crypt of the cathedral
in Lund, consecrated in
1123, is the oldest part
of Northern Europe's
largest Romanesque
edifice. The ceiling is
supported by 28 indi-
vidually carved stone
pillars, one of them said
to depict Finn the Giant,
the legendary builder of
the abbey.

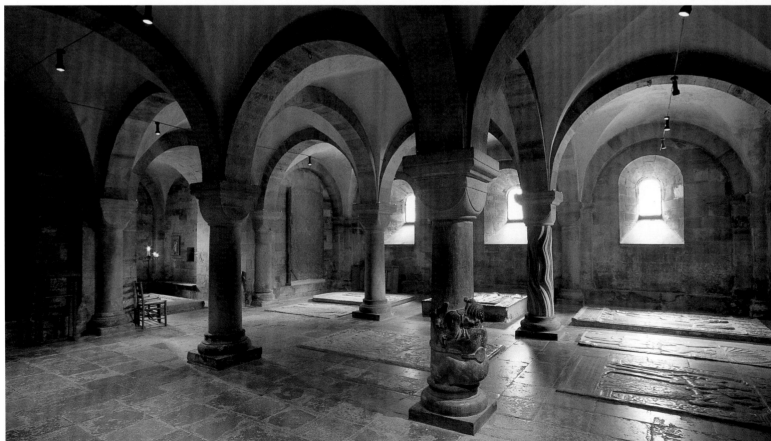

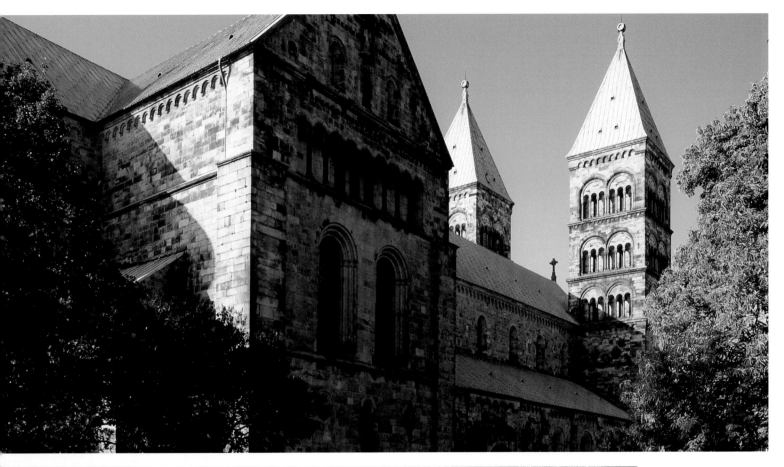

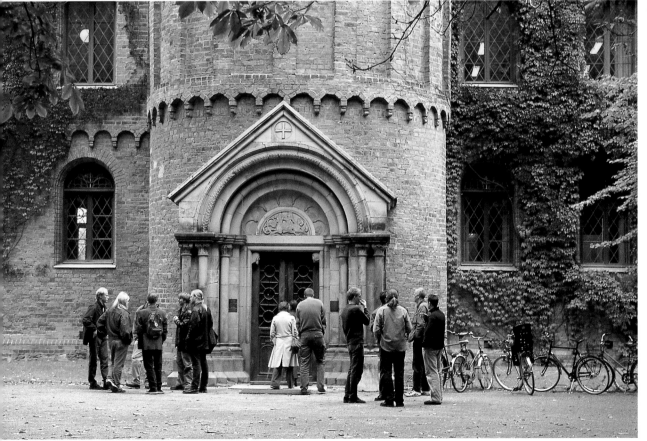

Above:
Since its consecration in 1145, Lund Cathedral has been frequently reworked and extended. Lund was made an archbishopric in 1103 and for many centuries was the cultural and religious centre of the north. During the 14th century there were 27 churches and seven monasteries in Lund alone.

Left:
The University of Lund's main building was erected in c. 1880. Northern Europe's largest university was founded much earlier in 1668, ten years after Skåne become part of Sweden, in an attempt to ease the subjugation of the area to Swedish rule.

Below:
When 12,000 years ago
Sweden emerged from
the icy wastes countless
lakes were formed, the
largest being perhaps
Vänern and Vättern.
The landscape of Småland
is also dominated by
expanses of moorland
and water, such as Lake
Mossjön shown here.

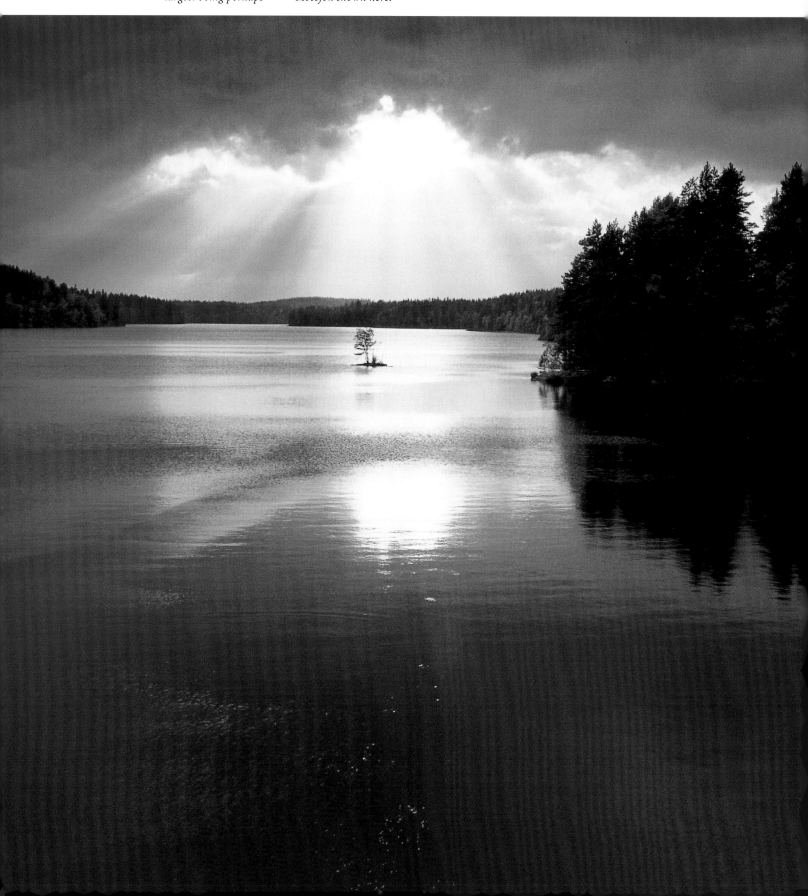

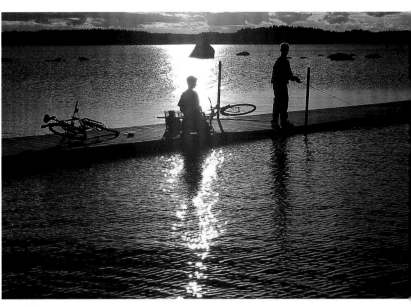

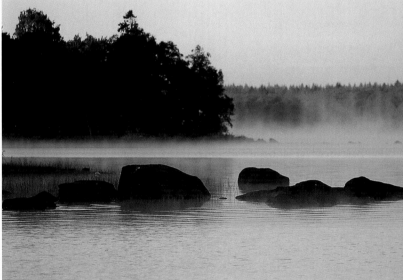

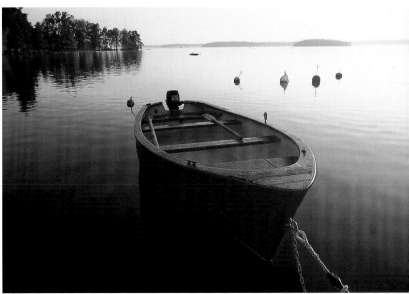

Top left:
This old house in the
Huseby Bruk Open-Air
Museum has an unusual
collection of artefacts

in its window. Other
buildings at the museum,
set in a fantastic park,
are used by artists and
craftsmen.

Bottom left:
Iron ore was originally
extracted at the Huseby
Bruk Open-Air Museum
in Småland, the first
furnaces for this purpos[e]
being built in 1628. The

40

ron was not only used to
make machines and tur-
ines, kilns and ovens in
Huseby itself, but also to
produce the first bicycles
n Sweden to be manu-
factured industrially.

Below:
No self-respecting,
typically Swedish house
should be without a
porch outside the front
door for removing
muddy footwear before
entering, as is still the
custom today.

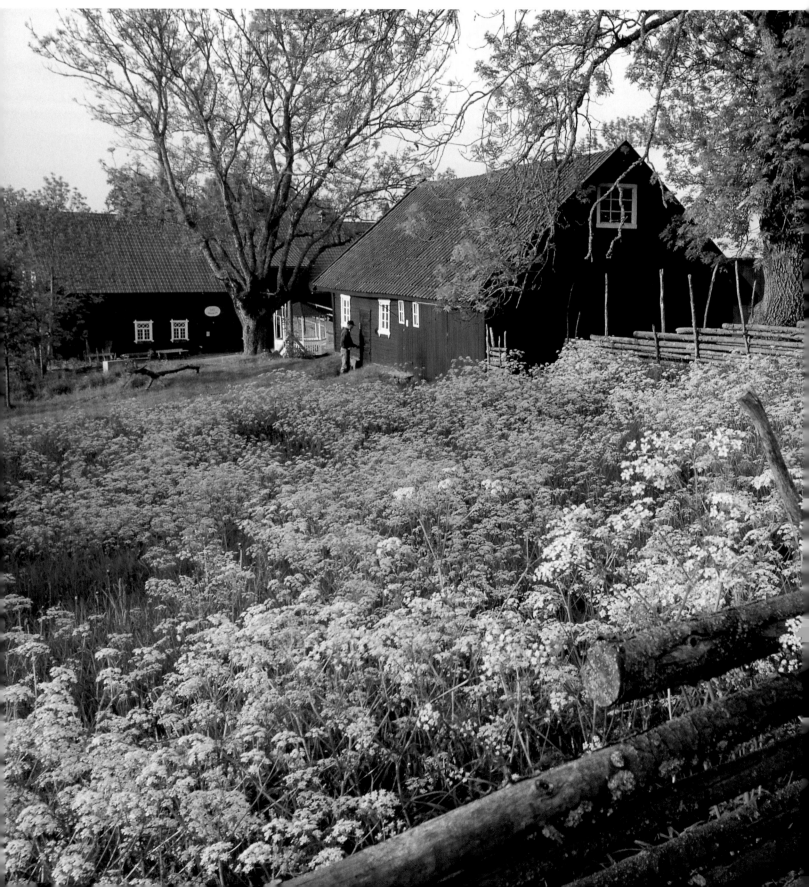

Below:
This is where dreams of Bullerby come true. Astrid Lindgren's book for kids, »The Children of Noisy Village«, was modelled on Sevedstorp; her father grew up here in Middle Farm.

Top right
The film of »The Children of Noisy Village« was also made in Sevedstorp considerably influencing the image Lindgren fans both great and small formed of Sweden

Centre right:
The main attraction of the little town of Vimmerby in Småland, where Astrid Lindgren was born in 1907, is the

Astrid Lindgren World theme park. The places she describes in her stories have been built here on a kids' scale of 1:3.

Bottom right:
Astrid Lindgren World in Vimmerby simply wouldn't be complete without Villa Villekulla, the home of freckle-faced, red-haired Pippi Longstocking.

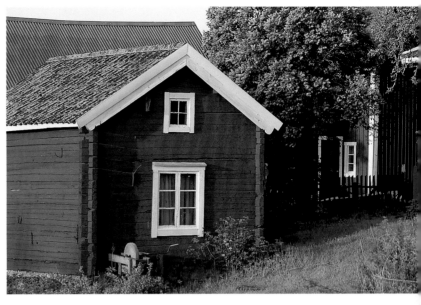

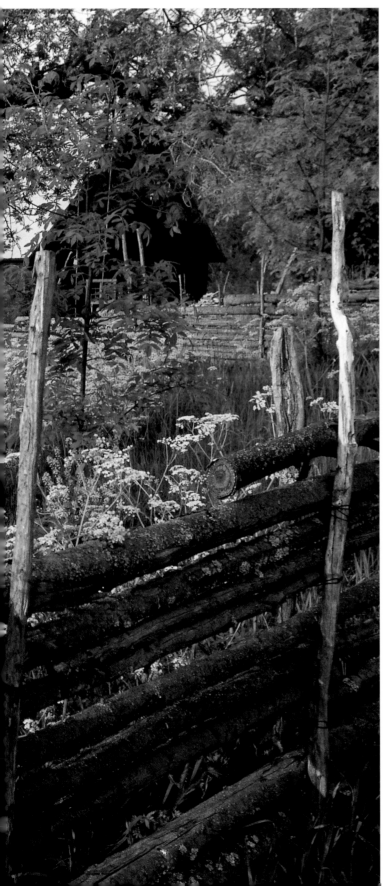

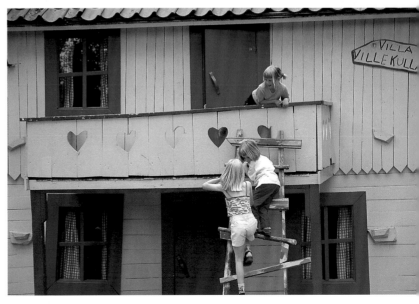

SWEDISH LITERATURE

Even if very early attempts at writing down the spoken word go back to the rune stones of the north, it wasn't until the last two centuries that Swedish literature really began to transcend the boundaries of Scandinavia. After the Norwegian Henrik Ibsen, August Strindberg (1849–1912) is the most performed playwright of the north. Son of a servant girl – as the title of his autobiography, »Tjänstekvinnas« son, unashamedly states – Strindberg's plays and prose were extremely critical of society, favourite targets being politics, art and the emancipation of women. With his early naturalistic plays and later symbolic, mystical works he made a lasting impression on the development of modern drama.

Despite his success Strindberg never received the Nobel Prize for Literature, as

In 1909 Selma Lagerlöf won the Nobel Prize for Literature. She first became known for her historic portrayal of life in »Gösta Berling's Saga«, with the story of little Nils Holgersson and his journey with the wild geese later earning her international acclaim.

opposed to Selma Lagerlöf (1858–1940). A schoolmistress from Värmland, Lagerlöf became famous through »Gösta Berling's Saga« (1891), a historic chronicle of life. Her best-known and most popular book, however, is »The Wonderful Adventures of Nils«, originally conceived as a fun geography textbook on Sweden for nine-year-olds, taking them on an imaginary journey from Skåne to Kebnekaise in Lapland and back. The resulting educational and literary masterpiece, also a classic »Bildungsroman« tracing Nils Holgersson's transition from nasty, small boy to reformed character, won Lagerlöf a Nobel Prize in 1909.

Strindberg and Lagerlöf may be well-known authors of renown, yet no-one is as avidly read nor has moulded Sweden's image across the globe as eloquently as Astrid Lindgren (born in 1907 near Vimmerby in Småland), probably the most successful

children's writer of our time. Just about everybody knows the stories of Pippi Long-stocking, Emil, Karlsson-on-the-Roof, Ronia, the robber's daughter and the Brothers Lionheart. When the word Sweden is mentioned, who doesn't immediately think of the watery landscape lovingly described in »Seacrow Island«, of the idyllic farmland where the children of Bullerby or Noisy Village reside or of Emil's Katthult in Småland? Lindgren's much younger colleague and illustrator Sven Nordqvist (born in 1946 in Helsingborg) has also instilled such enthusiasm in readers young and old with his detailed drawings of Old Man Potterton and his cheeky cat Findus that his stories have even recently been made into an animated film.

SWEDISH CRIME STORIES

Sweden also plays a not insignificant role in a completely different literary sphere. During the 1970s and 1980s it was the detective novels of Maj Sjöwahl and Per Wahlöö with their team of police, headed by the melancholy Inspector Beck, which documented

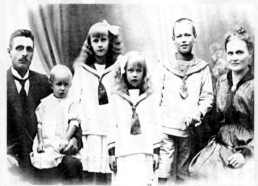

Astrid Lindgren with her parents, Hanna and Samuel August, and her three siblings: from the right, Gunnar, Stina, Astrid and little Ingegerd on her father's knee. Lindgren was born near Vimmerby in Småland. Her books are not direct transcriptions of her childhood memories, although many were inspired by tales her father had told her. No other writer has formed as vivid an image of Sweden as Lindgren has in her

books for children, despite the fact that she only started writing at the age of 37 when she began noting down the bedtime stories she made up for her sick daughter.

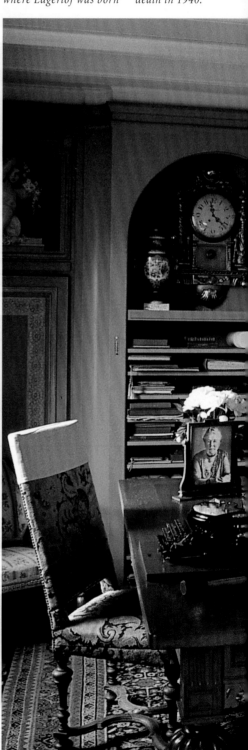

Below:
Selma Lagerlöf's study on the estate at Mårbacka has remained unchanged in homage to the Nobel Prize winner for literature. The house where Lagerlöf was born in 1858 had to be sold following the death of her father; with the money she made from writing Lagerlöf was later able to buy it back living there until her death in 1940.

Left:
In his breakthrough novel »Olof« Eyvind Johnson tells of his home of Norbotten, where he was born in 1900. Influenced by the stream- of-consciousness techni- que of James Joyce, his works are among the most popular and the most politically significant in Swedish literature.

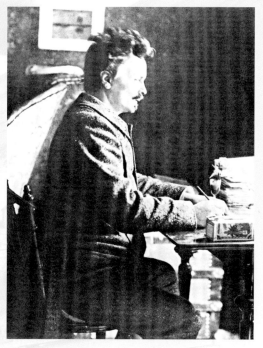

August Strindberg at his desk in Lund in 1897. In Strindberg Sweden had its first urban poet who worked the natural sur- roundings and land- scape of his homeland into his writing and exerted a great influence on the next generation of literati, among them Friedrich Dürrenmatt and Peter Weiss.

the defects in Sweden's society of the day; today, Henning Mankell's Inspector Wallan- der, a man plagued by human weakness, in- security and grave social misgivings, now tops the bestseller lists.

In the 1960s crime writer Kerstin Ekman made something of a name for herself with her complex studies of people and the circles they move in. Strong women feature in her »Witches' Rings« series which exposes the constraints and obligations imposed on the lives of ordinary people, a series considered to be the most significant epic of contempo- rary Swedish history. Kerstin Ekman was even made a member of the Swedish Academy in 1978, an honour previously bestowed upon just two women.

With just 8.8 million inhabitants, com- pared to other countries the relatively small populace of Sweden has turned out a consid- erable number of Nobel Prize winners. With Selma Lagerlöf at the helm, the list goes on to include lyric poet Verner von Heidenstam, Erik Axel Karlfeldt, Expressionist Pär Fabian Lagerkvist and poet Nelly Sachs, a Swedish immigrant born in Berlin.

The area between Nybro and Växjö in Småland is known as Sweden's »Glasriket« or glass kingdom. At over 40 »glasbruk« (glassworks) you can watch crafts-men at work, such as here in Kosta Boda, and buy high-quality Swedish glass, the mark of top design.

Lessebo near Boda is home to another ancient traditional Småland craft. At the old »hand-pappersbruk« you can watch what is now our standard writing mate-rial being manufactured and purchase hand-made notepaper, decorative wrapping and cards as a souvenir.

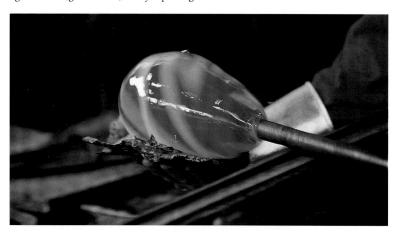

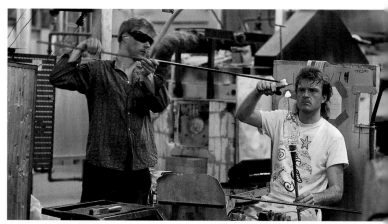

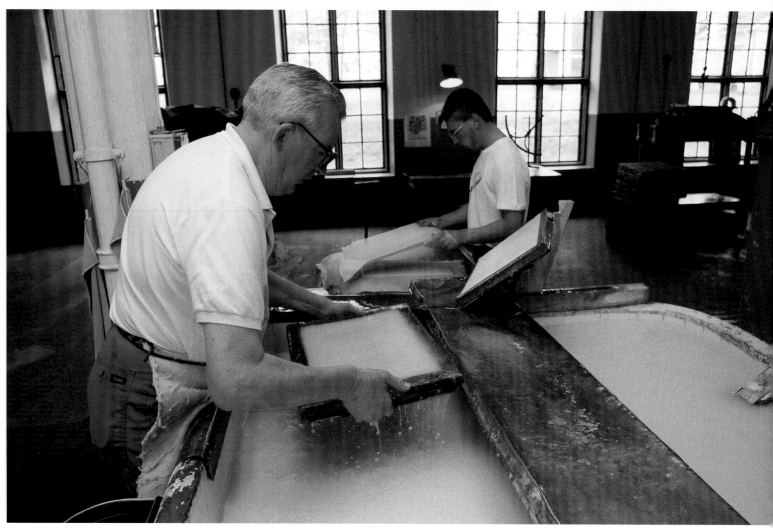

Below:

The Tändsticksmuseet in Jönköping pays tribute to the great age of the matchstick at the end of the 19th century. Housed in the oldest matchstick factory still in existence from 1848, the museum charts its manufacture from the industrialisation of production in 1890 to the factory's closure in 1971.

Bottom:

The invention of the match by the Lundström brothers turned Jönköping into a humming centre of matchstick production. The matchstick museum also documents the history of the world-famous Jönköping wood which homeworkers in local cottage industries made matchstick boxes and labels out of.

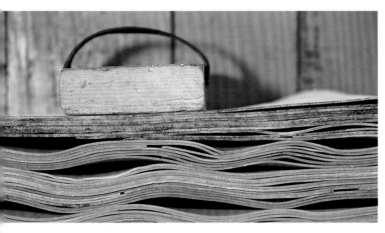

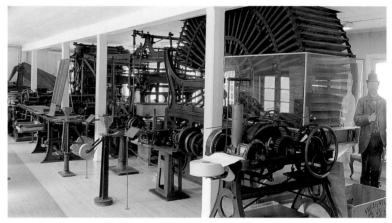

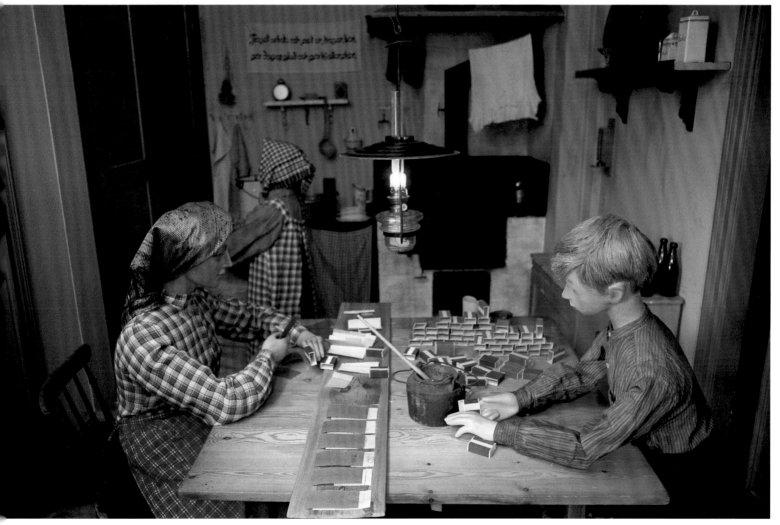

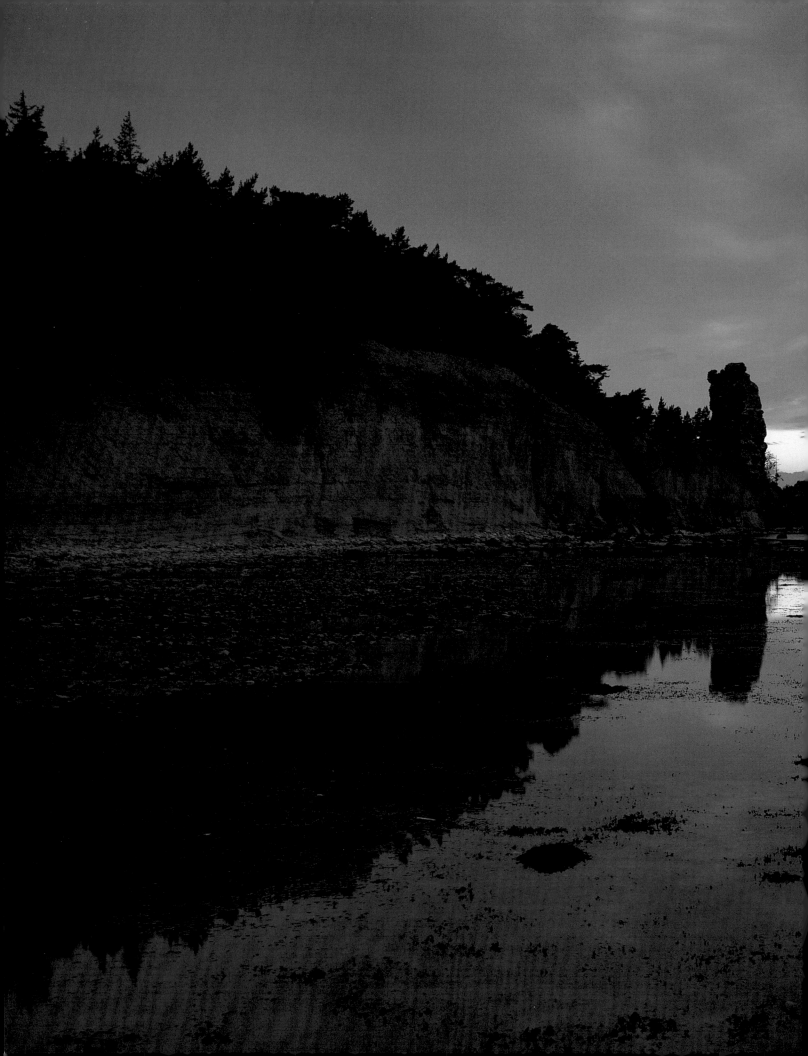

The Jungfruklint near Lickershamn on Gotland is the product of coastal erosion by the Baltic Sea. Seven metres (23 feet) high, the »maiden's rock« is the tallest »raukar« or limestone stack on the island.

Below:
Trawlers still set out to sea from the sleepy harbour of the old fishing village Lickershamn on Gotland's northeast coast.

Top right:
The »raukar« are not the only reason for visiting the coast near Lickershamn. Fossilised remains of the creatures who inhabited the sea 400 million years ago can still be found along its secluded shingle beaches.

Bottom right
Gotland's bigges satellite island, Fårö 139 square kilometre (53 square miles) i size, boasts the large number of bizarre roc formations or »raukar« such as here nea Langhamma

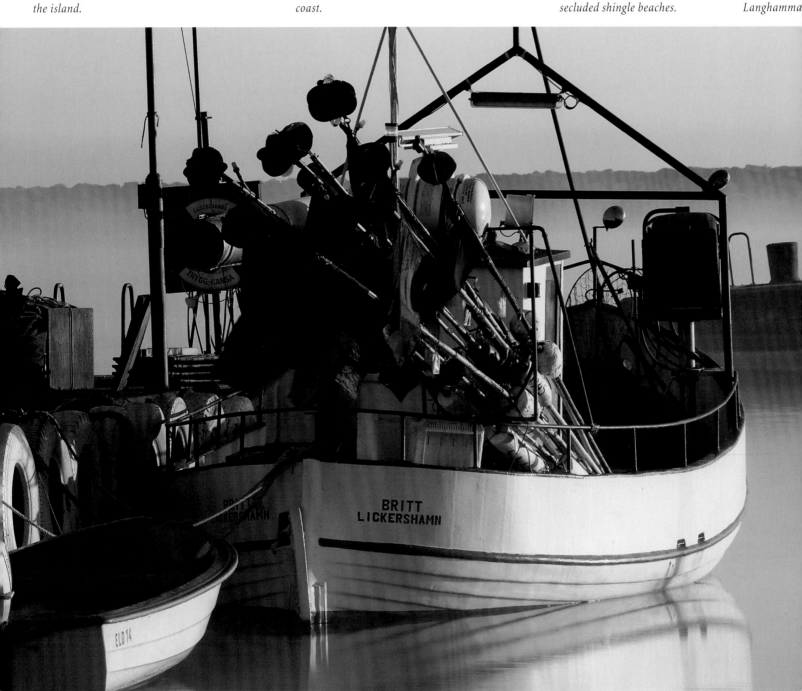

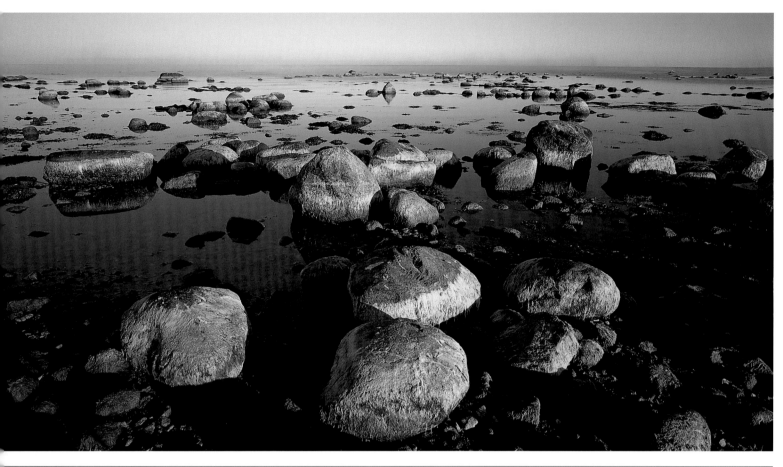

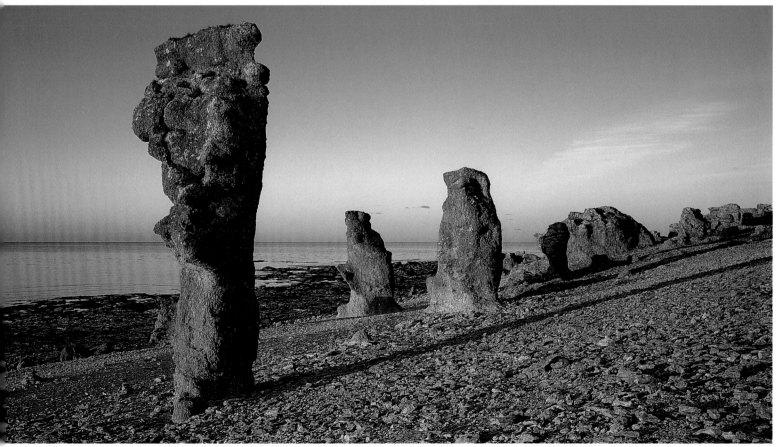

51

With its fertile soil Gotland lives off the land, as the many relics of its farming past clearly document. Old farmhouses and wooden windmills, such as these on the island of Fårö to the north of Gotland, are dotted about the countryside.

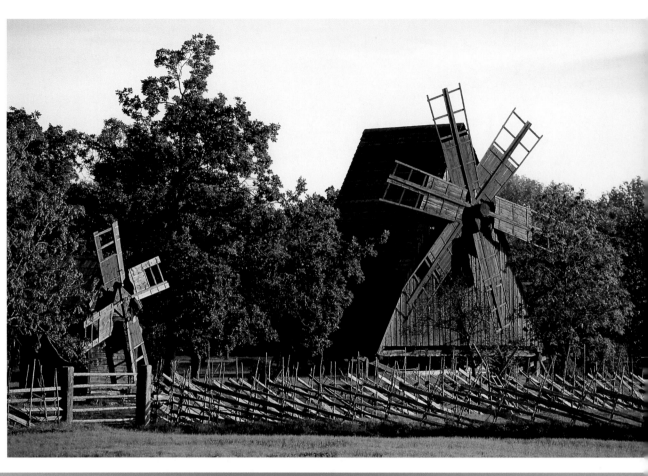

Below:
The little fishing village of Hallshuk, perched on Gotland's most north-westerly point, is set in fantastic yet extremely isolated surroundings. Hallshuk marks the northern boundary of the Hallhangvar nature reserve.

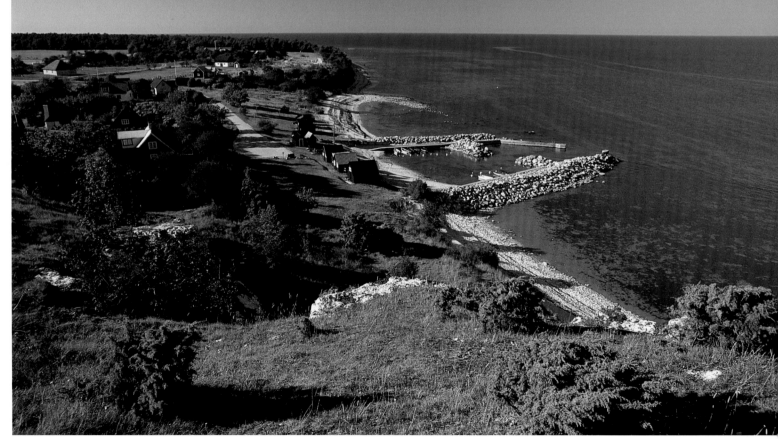

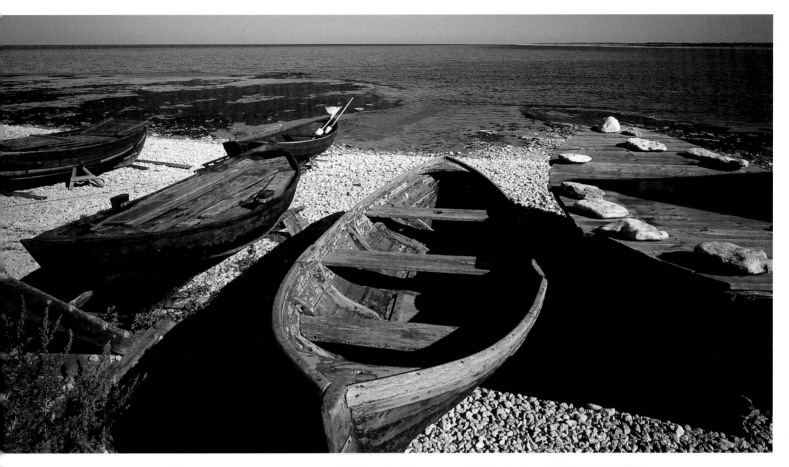

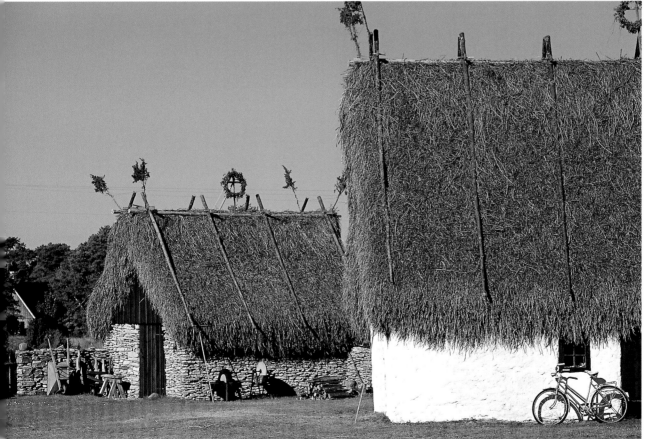

Above:

The people of Gotland saw themselves as farmers rather than fishermen, only trawling the sea at certain times of the year to supplement their diet and income. The »fiskeläge« you stumble across on Gotland are more a motley collection of huts and boat sheds, often abandoned in the 1950s, than proper fishing villages.

Left:

The many historic farms on Gotland show just how important farming is for the inhabitants of the Baltic's largest island. The percentage of Gotland residents working in agriculture is still considerably higher than the national average.

Scandinavia provides us with important information on the ancient mythology of the Germanic world. By the 8th and 9th centuries most of the people of Europe had been converted to Christianity, with only the north still in the grip of pagan gods who personified war and fighting, demanding bloody sacrifice from those who worshipped them.

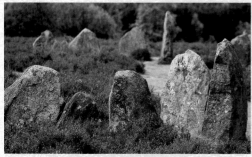

These attributes are perhaps explained by the fact that particularly during the great migration of the peoples a permanent state of violent unrest prevailed which was mirrored in the myths and legends of the Germanic tribes. Scandinavia was a long way from the clutches of Rome and thus a late convert to Christianity, meaning that many relics of the ancient Norse religion have been preserved.

SNORRI STURLUSON'S »EDDA«

One source of Germanic mythology is a 13th-century manuscript known as the »Elder Edda«. A second valuable source of information is provided by the »Prose Edda« of Snorri Sturluson from Iceland, a guide to the Germanic gods Snorri compiled in an attempt to educate his contemporaries.

The oldest manuscript of the »Prose Edda« goes back to c. 1280. The »Edda« describes the names and legends of the Aesir, the mightiest tribe of gods in ancient Norse mythology.

Left:
Over 600 stones allegedly once stood on the burial ground at Vätteryd. Today there are just 150, *some of them arranged in the shape of a ship, dating back to the early Iron Age and the time of the Vikings.*

Below:
The rock carvings (häll-ristningar) in Vitlycke near Tanum were made a UNESCO World Heritage Site in 1994. They originated between *1500 and 500 BC. The pictures suggest that the people of the time lived from the breeding of livestock, hunting and fishing and also from crop farming.*

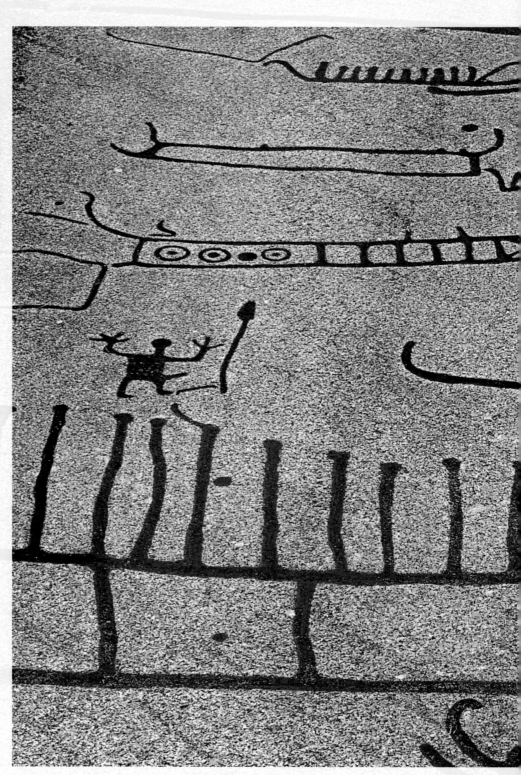

Right:
At the Historika Museet (historical museum) in Stockholm you can learn all about prehistoric times in the north of

Europe, from the Stone Age 6,000 years ago to the Middle Ages. Rune stones usually signify for whom and for what purpose a stone was erected.

THOR, THE GOD OF THUNDER

Thor was below Odin in the hierarchy of the deities yet was more popular than his superior. He is usually portrayed as a mighty figure with a long, red beard and a fierce glint in his eyes, extremely irritable and extremely strong. In his hand he holds his hammer Mjölner which always returns when thrown. Despite his fearsome appearance he is well-disposed towards mankind, fighting the giants and trolls who threaten the mortals of Midgård, especially the dreaded World Serpent Jörmungand, who lies at the bottom of the ocean and is capable of encircling the entire kingdom of the human race in its slippery body. When Thor wields his hammer on his various crusades up in the kingdom of the gods, there is thunder and lightning on earth. Thor's popularity is manifested in the many amulets which have been found sporting his legendary weapon.

Sources suggest that the third most important god in Swedish Norse mythology was Freyr. He also had a female counterpart, his twin sister Freyja, who had the power over life, love and death. Freyr, also the god of the sun and the rain, was obviously so important that his statue merited a place alongside those of the more popular Odin and Thor in a large temple in Uppsala which the first missionaries to Sweden described in reports of their travels. Little is known about the actual form worship of these gods took, as the Christian preachers found it too obscene to go into detail about rituals associated with a god of fertility.

The Scandinavian gods bore certain similarities to those of the Greeks and Romans, and even to those of India, yet there were many traits which were specifically related to the violent and heroic age of the Vikings. Although the world of the Aesir has long been usurped by Christianity the legends carry on, with new remnants of Sweden's heathen past still occasionally coming to light. The days of the week are not Sweden's sole recollection of Norse mythology; in children's fairytales the old adversaries of the gods, the giants, trolls and dragons, are very much alive.

The chief gods were the Aesir tribe. They had many human characteristics and were often locked in fierce competition and conspiracy; they loved drinking and celebrating and fought their foes, giants, trolls and the dangerous World Serpent Jörmungand, with vehemence and bravery. The gods lived in Asgård, the kingdom of the Aesir which housed the castle of Valhalla, Odin's great hall and Bilskirnir, the house of Thor. The Germanic conception of the world treated this kingdom of the gods as the highest of three domains; mere mortals lived on earth or Midgård, the kingdom of the people, surrounded by the oceans, beneath which was Niflheim, the kingdom of the dead. The kingdoms of the gods and of the people were connected by a bridge called Bifröst which Snorri Sturluson described as a rainbow illuminated by flames.

The three chief gods of ancient Sweden were Odin, Thor and Freyr. Their importance is echoed in the modern Swedish names for the days of the week: »onsdag« (Wednesday), »torsdag« (Thursday) and »fredag« (Friday). Our corresponding words in English also contain references to these gods; Wednesday is a mutation of Old Norse »ódinsdagr«, (day of Odin), Thursday a corruption of Thor's Day, Thor being the god of thunder, and Friday the day of Freyr, the god of fertility. Odin as head of the gods was first and foremost a god of war to whom sacrifices were made to ensure strength and good fortune in battle. Those who died bravely went to Valhalla, Odin's hall of the slain, where they were received by the Valkyries. Odin was not a gentle father guarding his flock but a powerful, dangerous, zealous protector of mankind, as his other names Svipall (the Capricious), Baleygr (the Smouldering Eye) and Vidurr (the Destroyer) suggest. He was, however, also the god of wisdom and a master magician. Odin had two ravens, Hugin (Thought) and Munin (Memory), whom he taught to speak, sending them out into the world to tell him what they saw.

Rock carving of Thor, the god of thunder, second only to Odin, the chief god of the Aesir. With his great physical strength Thor was charged with protecting the kingdoms of the gods and the people from giants and monsters.

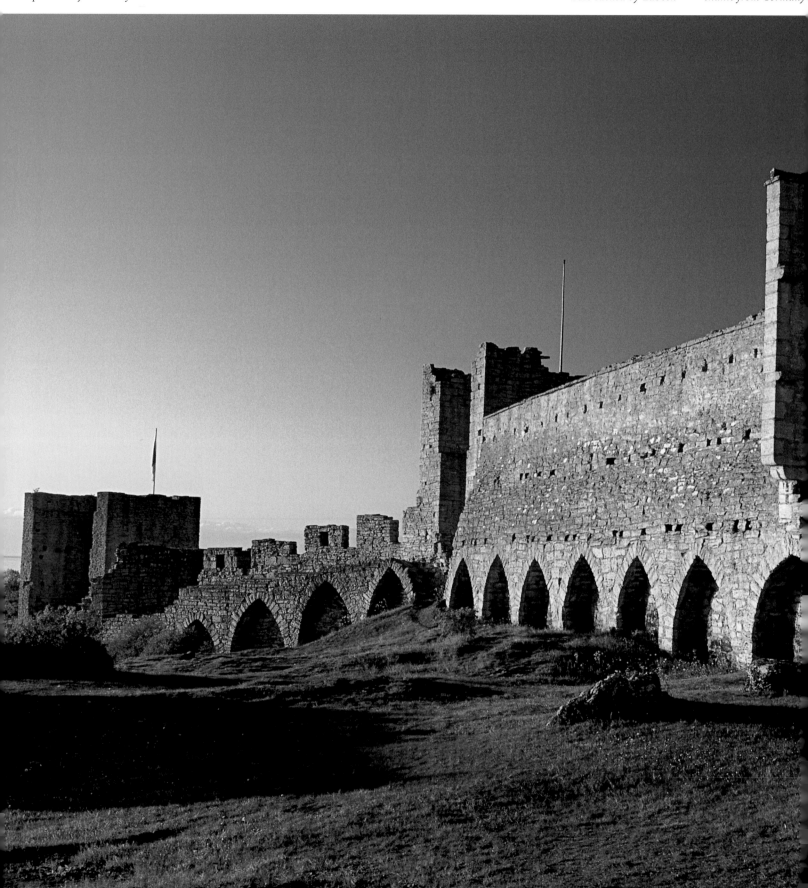

Centre right:
The frieze adorning the portal of the Romanesque cathedral church in Visby depicts several stories from the Bible, among them Mary and Joseph's flight to Egypt with the Baby Jesus.

Bottom right:
With its crockets, finials and structured robes, the richly ornamented doorway to Visby's cathedral church has more of the early Gothic than the Romanesque.

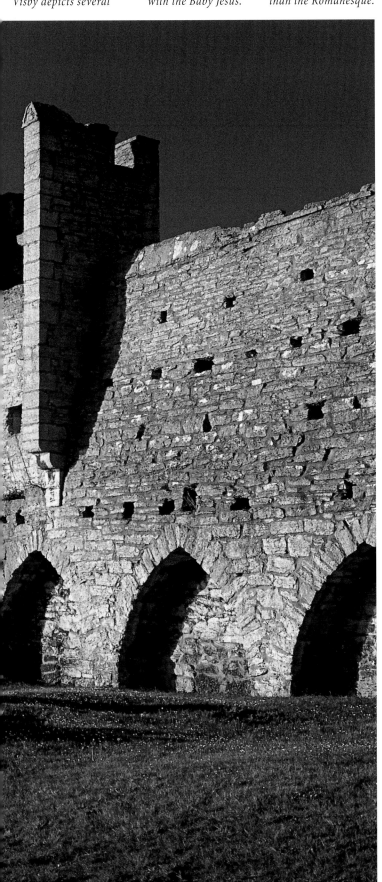

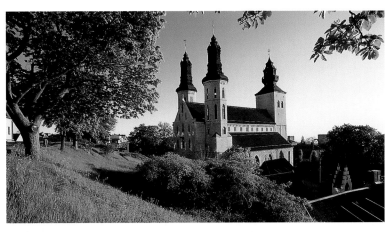

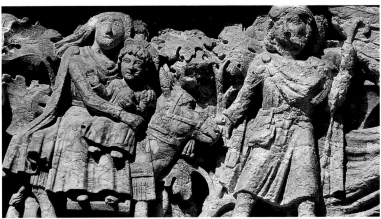

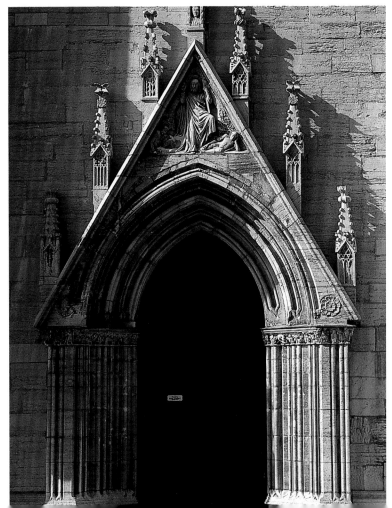

Below:
Sweden has around 100,000 lakes splattered across its surface, one more beautiful than the other. With white clouds dotting the perfect blue sky, it's easy to sit back, relax and let the world go by – perhaps here at this lake near Tidersrum in Östergotland.

Top right:
Wood is not just used to build many of Sweden's characteristic log cabins but also to heat them particularly out in the country

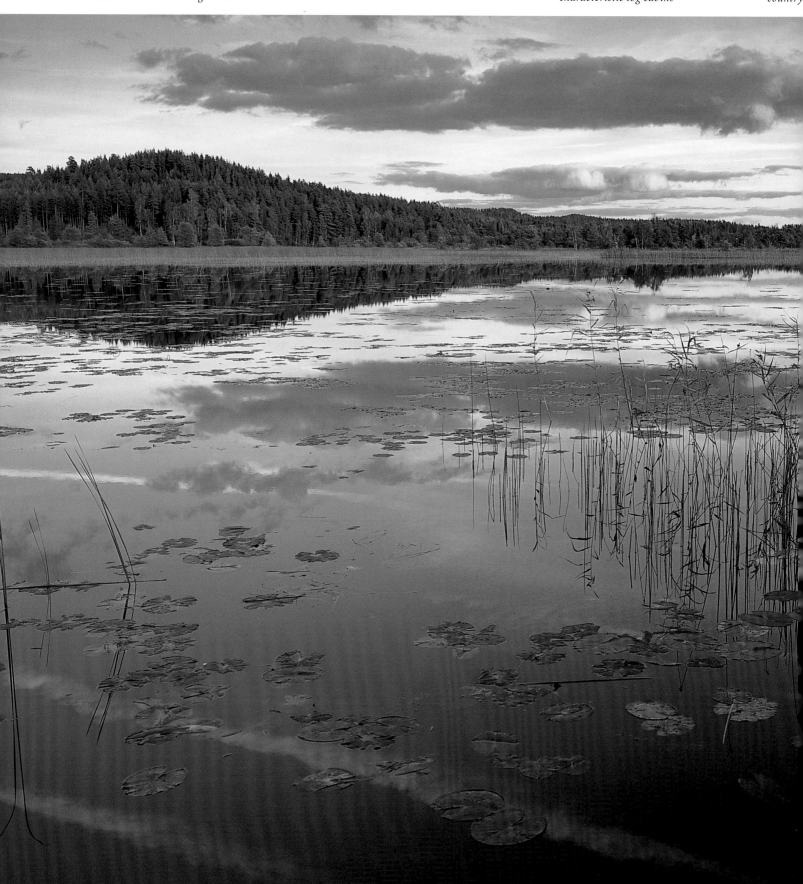

Centre right:
*Östergotland boasts a
variety of scenery, from
the cornfields near
Rydsnäs to the three
great lakes of Boren,
Roxen and Glan.*

Bottom right:
*The province of Öster-
gotland is a patchwork
of old farmhouses,
historic monuments and*
*areas of great natural
beauty. It's also home to
Sweden's largest animal
park, Kolmården.*

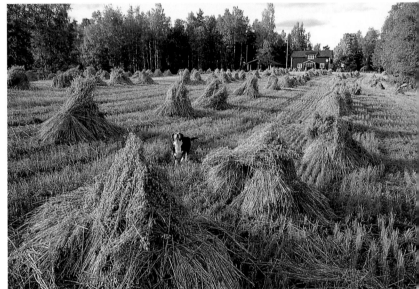

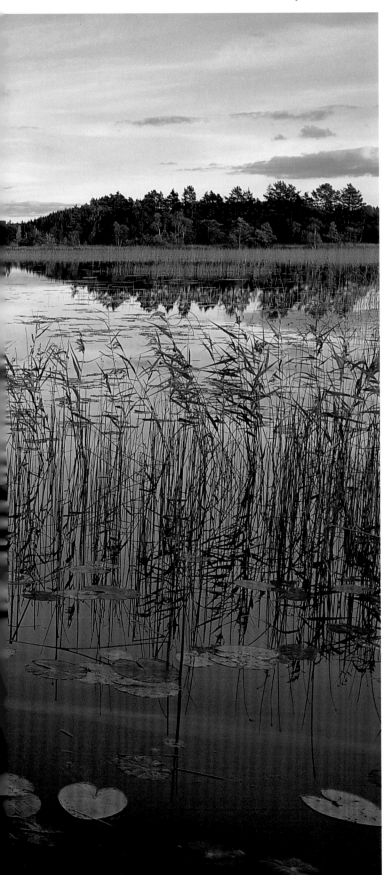

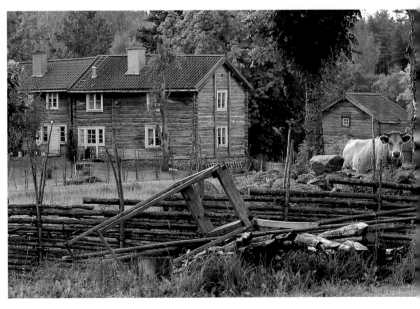

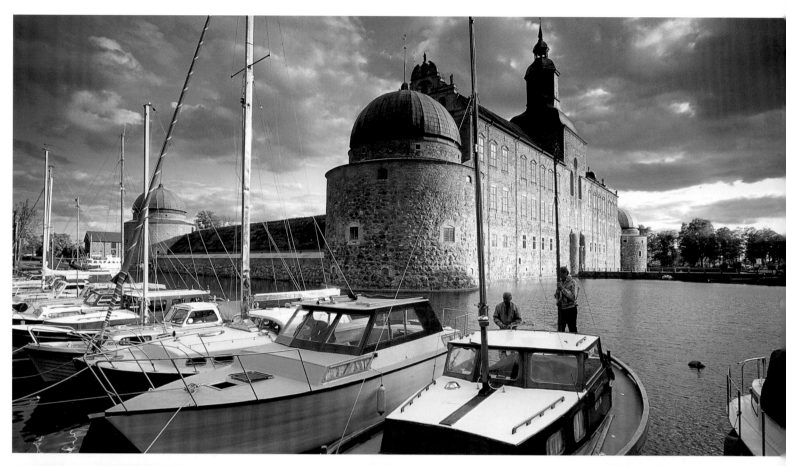

eft:

*he moated castle of
adstena, wonderfully
tuated on the shores of
ake Vättern, was erected
y Gustav Vasa in 1545.
he squat round towers
re typical of the Vasa
rchitectural style.*

Below:
*Taking a break at
Mariestad, the «pearl of
Lake Vänern«. The little
town with its 17th-century
wooden houses and*

*Marieholm Palace was
founded in 1583 by
Karl IX, later king, and
named after his wife
Maria, who was from the
Palatinate in Germany.*

eft:

*iew from one of the
indows of Läckö Castle
n the Kålland penin-
ula jutting into Lake
änern. In 1615 Gustav
asa gave the county of
äckö to his commander
cob Pontusson de la*

*Gardie, whose son turned
the existing building
into the present Baroque
palace. 248 rooms attest
to the great luxuries
afforded during
the period of Swedish
supremacy.*

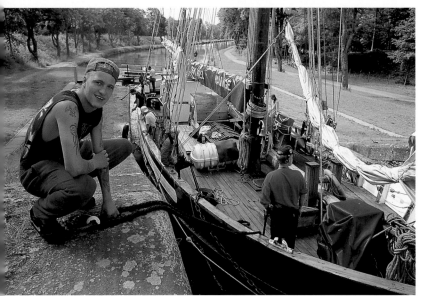

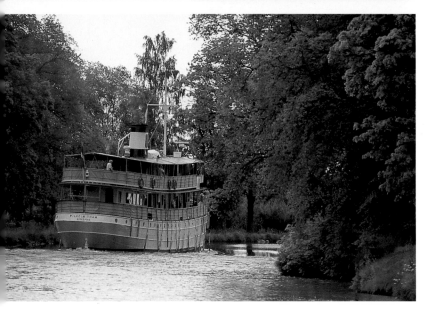

Left:
The many locks along the Göta Canal linking the North and Baltic seas, a major shipping channel up until 1978, are now only negotiated by water sports fanatics, anglers and hikers. If you don't fancy sailing your own craft along it why not take a trip aboard one of the historic white canal cruisers (bottom left)? The cana was begun in 1810 by Baltzar von Platen, who needed over 20 years and 58,000 labourers to complete the mammoth project.

Below:
Motala, a harbour town on the eastern shores of Lake Vänern, owes its existence to its location at the mouth of the Göta Canal. Planned in the shape of a fan by Baltzar von Platen, the builder of the canal, one of Motala's major attractions is the canal and maritime museum which documents the history of Sweden's most impressive inland waterway.

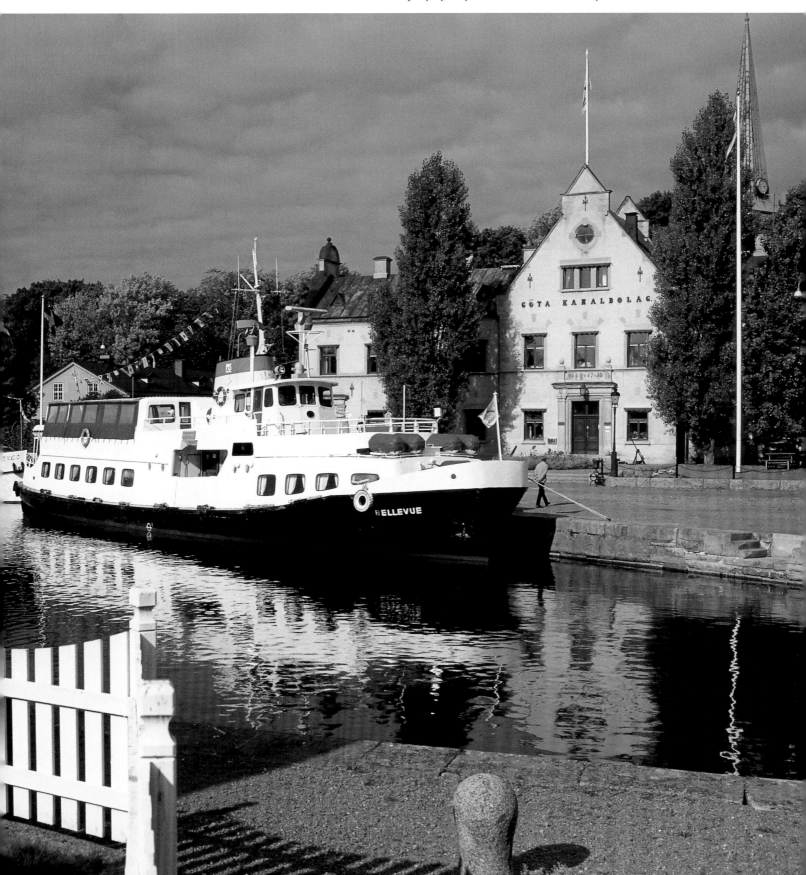

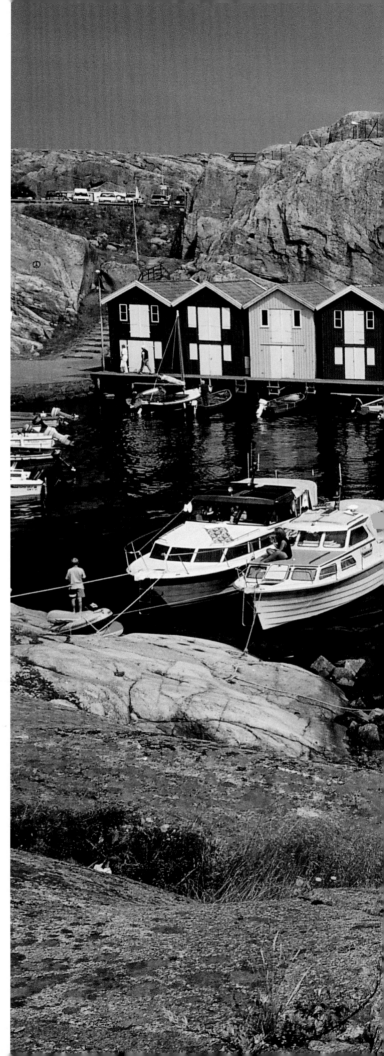

Right:
The bright wooden huts
lining the quayside or
»Smögenbryggan« along
the busy harbour and
the spectacular rocky
setting make Smögen in
the province of Bohuslän
a popular seaside resort.

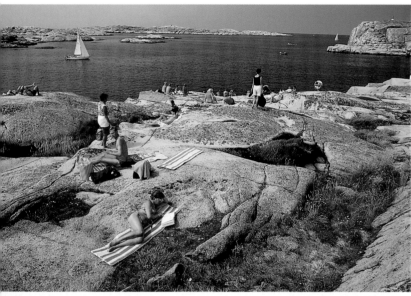

Above and top:
The granite rocks along
the Bohuslän coast near
Smögen are packed with
sun worshippers soaking
up as much light as pos-
sible to get them through
the dark winters.

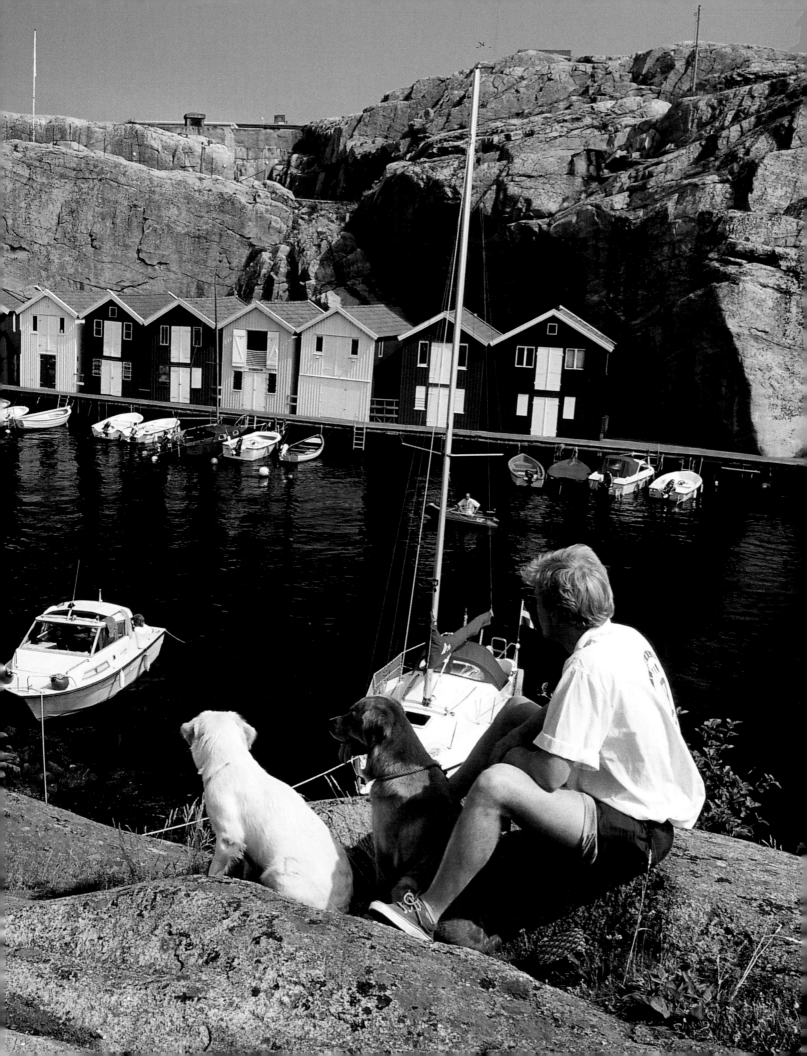

Right:
There's a grand view from Café Utkiken (outlook) at the top of the «skyscraper» in Lilla Bommen harbour in Gothenburg. You can see out over the town and harbour which was founded by Gustav II. Adolf in 1624 and is now the second-largest city in Sweden.

Below:
The wood-panelled interior of the opera house on Packhuskajen in Gothenburg has an enormous glass facade through which you can watch the evening lights glittering on the water. It was opened in 1994 and is famous for its excellent acoustics and technical finesse.

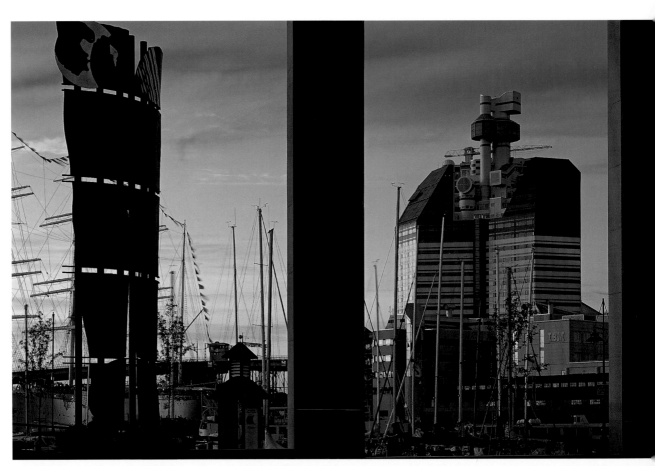

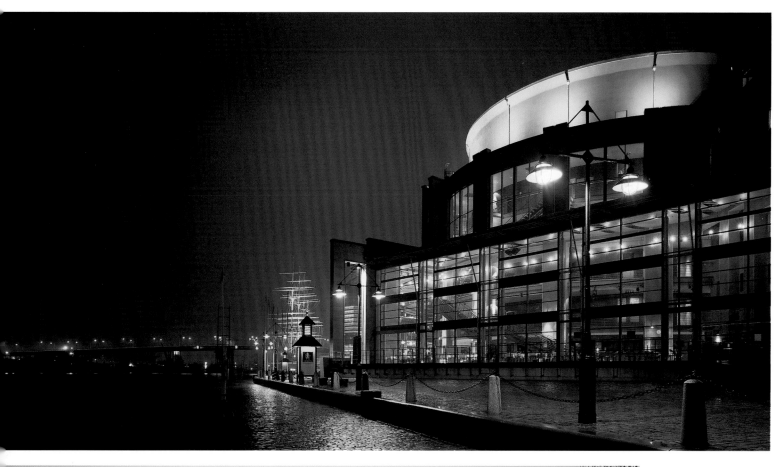

Above:
From the outside the glass-and-steel architecture of Gothenburg's opera house is no less impressive. Built to look like a ship in deference to its harbour location, it is justifiably said to be one of the most resplendent music theatres of the modern age.

Left:
View of Gothenburg which has the largest harbour in Sweden, the mild climate in this part of the country ensuring that the water remains unfrozen all year round. In the foreground is a typical wooden Swedish house, the like of which are also found in the big cities, with the Ullevi sport stadium lit up in the background.

The founder of Skansen Open-Air Museum on the Stockholm island of Djurgården, Artur Hazelius, even had an entire 18th-century church rebuilt in situ. In 1891 Hazelius decided to start collecting important examples of folk architecture and artefacts in Sweden, re-erecting c. 150 buildings from all over the country at his museum.

Central Sweden or Svealand is dominated by water; lakes Mälaren, Hjälmaren and Siljan and the rivers Dalälv and Ljusnan flood the landscape. Castles, palaces and old manor houses, remnants of Sweden's age of supremacy, occupy clearings in the wild expanses of forest. Squeezed in between the northernmost reaches of lakes Vättern and Vänern, with Västergötland to the south, the province of Närke is also a land of water, with its huge Lake Hjälmaren as big (yet nowhere as deep) as Lake Constance. At just 4,500 square kilometres (1,737 square miles) in size, Sweden's smallest province was also long the subject of public debate as to whether it should be included as part of Svealand or allotted to the more southerly Götaland. Värmland, the home of Selma Lagerlöf, is divided by the great river of the north, Klarälv, along which wooden rafts can travel from Norway to Lake Vänern. Filipstad in Värmland is where that great Swedish export, Wasa crispbread, comes from. Pure, unadulterated Sweden can be found in Dalarna, its scenic highlight undoubtedly Lake Siljan and the 3,000-foot mountains rising up towards Norway. Ancient customs and traditions have been well-nurtured in this the most northerly region of Svealand, with building styles, local costumes and even fiddle music handed down from generation to generation. The provincial capital Falun with its mines is well-known from the story by Johann Peter Hebels, in which the body of a miner, buried under a collapsed seam, is found perfectly preserved 50 years after his death. Along the east coast lie the provinces of Södermansland or Sörmland and Uppland with Uppsala, the first royal capital of the Swedish kings. Here are the skerries of the east and the lake districts of Mälaren and Hjälmaren to the north and west. With capital Stockholm, the »Venice of the North« balancing on its 14 islands, this is one of the most densely populated areas of the country. West of central Uppland is Västmanland, the land of the men from the west, as opposed to Södermanland, the land of the men from the south.

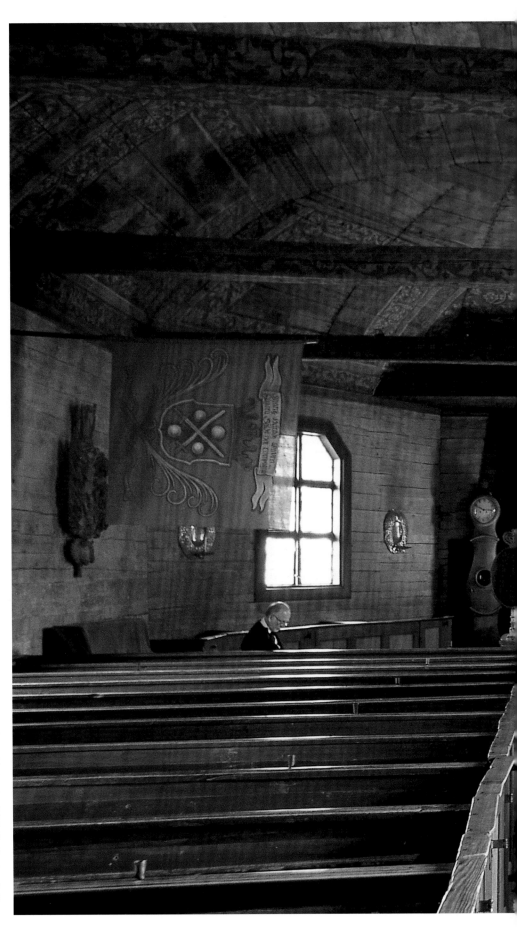

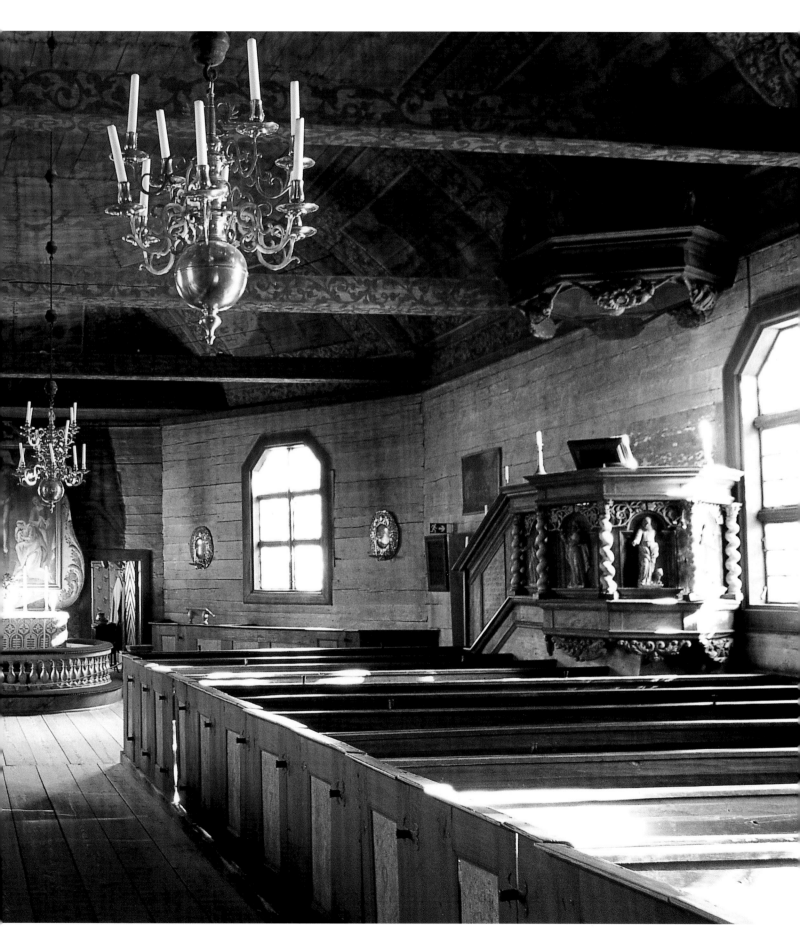

Above:

This farm is on the Klarälv, said to be the most beautiful river in the province of elongated lakes and rivers, Värmland. The rivers, the abundance of iron ore and the vast areas of spruce and pine forest are the »gold« of Värmland and largely responsible for the region's economic boom.

Right:

After a tour of Norberg this cosy café is an inviting place to sit down and have a rest over a coffee and »kanelbullar« or cinnamon slice. During the 15th century the area around Norberg in Västmanland was Sweden's major mining region.

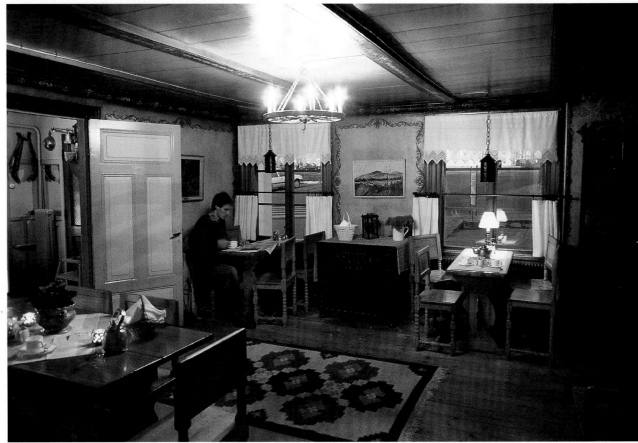

Left:
Wood was and is an important raw material in Sweden, used to heat and build the country's typical log cabins, to fuel the furnaces at the ironworks, as a major export and to make Swedish matches.

Below:
The red cabins of Rättvik on the shores of Lake Siljan in Dalarna glint in the evening sun. Rättvik is known for its folk music and folk dancing, the highlight of the year being the folk music festival »Musik vid Siljan« held here in July.

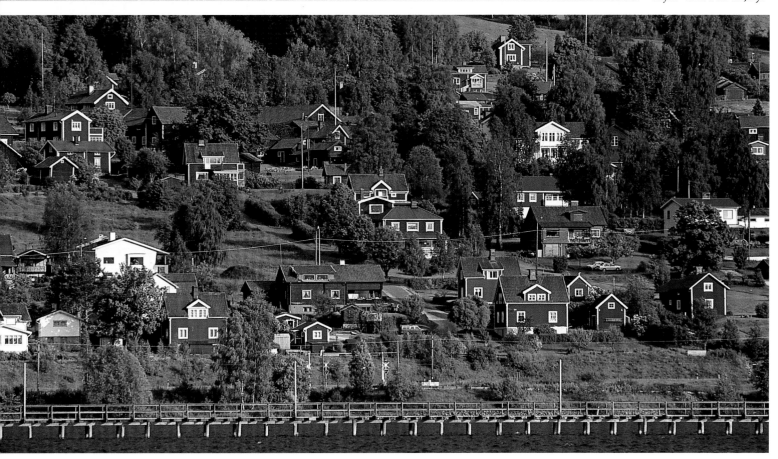

The famous Långbrygga at Rättvik stretches 628 metres (2,060 feet) out into Lake Siljan, the water near the shore being too shallow for boats to moor. Now a reconstruction of the original, the landing stage has had steamers docking here for around 100 years.

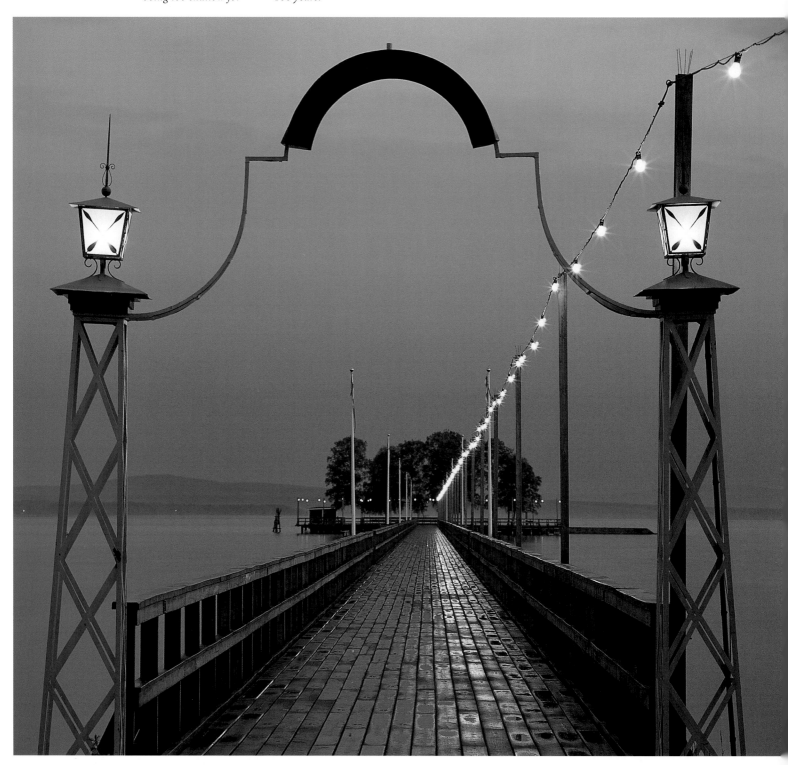

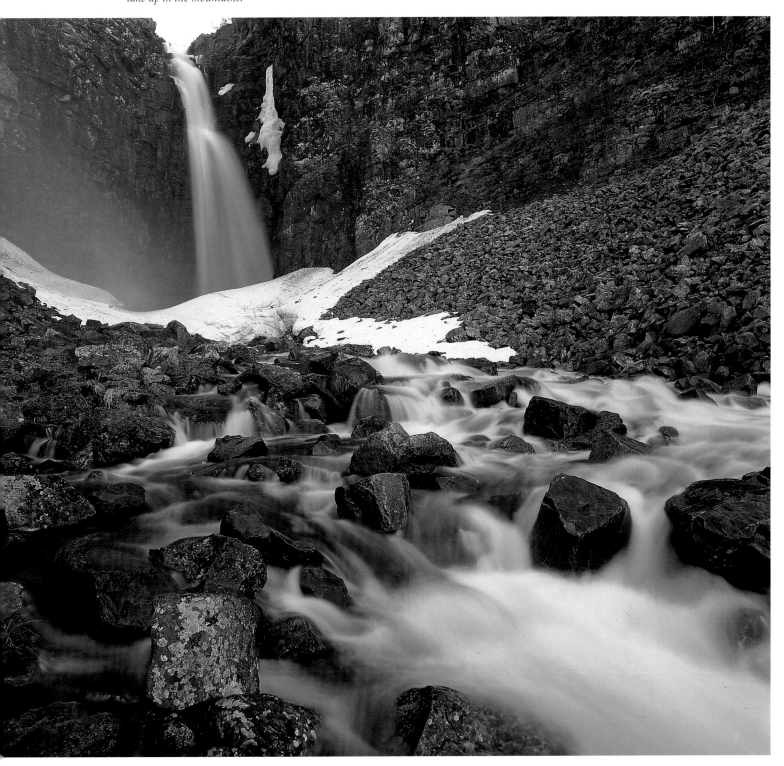

Not far from the remote forest hamlet of Särna in Dalarna the Njupeskär Falls forge their way down the valley from a lake up in the mountains.

In northern Dalarna, Jämtland and Lapland there are still a few hundred brown bears living in the wild. If you want to be sure of seeing one, visit the largest bear sanctuary in Europe in Grönklitt near Orsa, Dalarna, where relatives of Pooh, Paddington and co. romp around in spacious surroundings with wolves and lynx.

Although the road to the falls at Njupeskär near Särna, Dalarna, is often rocky, the view at the end of it is well worth the effort.

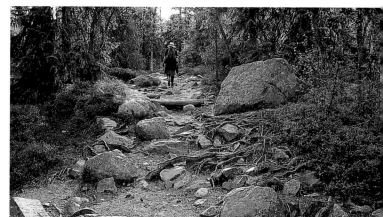

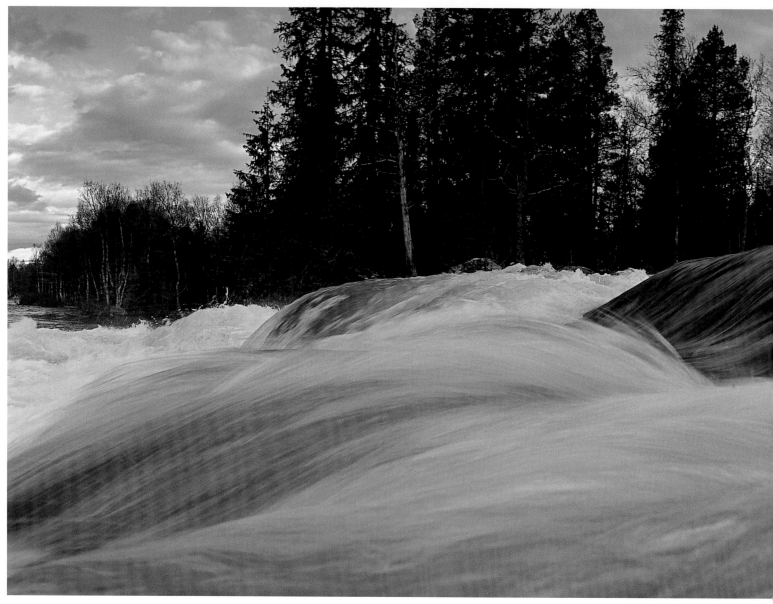

The little village of
Värna is surrounded by
thick jungle almost
untouched by man.

Near Sysslebäck Värm-
land's most scenic river,
the Klarälv, meanders
through endless forest,
providing ideal conditions
for grayling and salmon
trout fishermen.

Bottom:
Impressive rapids tear
along the breathtaking
Grövelsjön River which
cuts through a remote
hilly landscape on the
Norwegian border. The

river region is one of the
best hiking, canoeing
and fishing areas in the
country and is also
popular for winter sports.

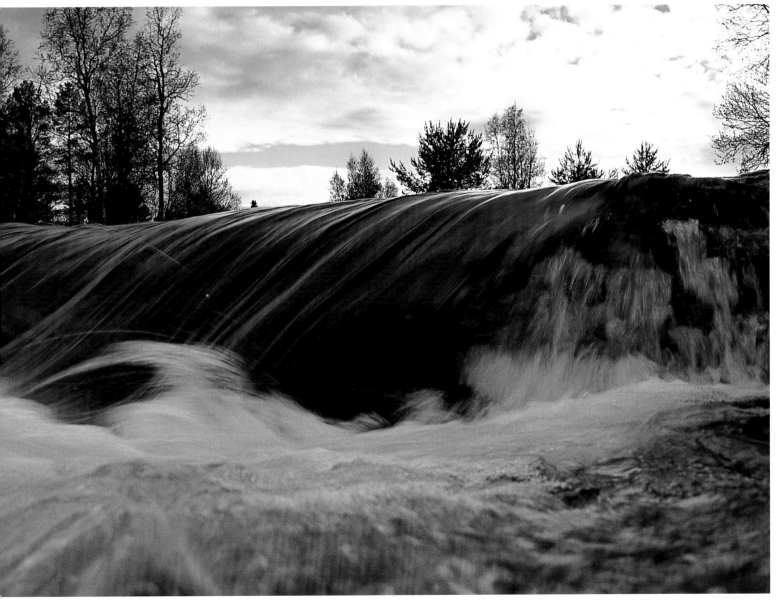

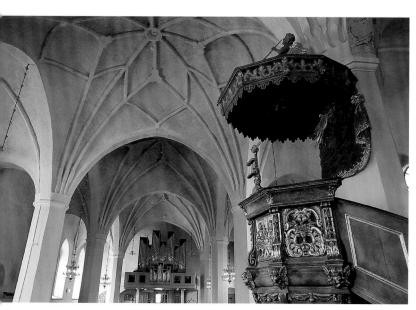

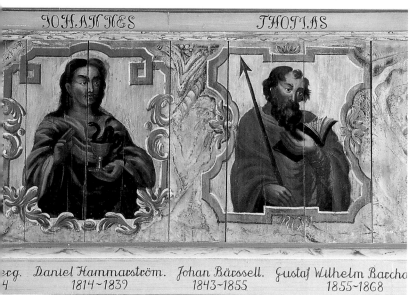

JOHANNES THOMAS

Daniel Hammarström. Johan Bärssell. Gustaf Wilhelm Barcho
1814~1839 1843~1855 1855~1868

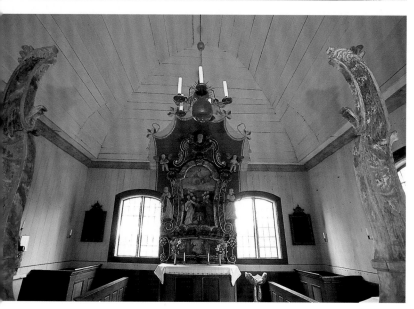

Top left:
The late Gothic vaults of the church in Mora are 15th century. The church itself was remodelled in 1673. The free-standing clock tower from 1672 is one Lake Siljan's local landmarks.

Centre left:
The scenes from the Bible adorning the pan frescos in the church at Rättvik have been tran

Bottom left:
*Even though Särna is
nothing more than a
hamlet, its wooden
shingle church built be-
tween 1684 and 1697 is
splendidly furnished.*

...ted into local Dalarna
...ulture, with some of the
...gures wearing frock
...oats and top hats.

Below:
*Parts of the church in
Rättvik on Lake Siljan,
with its white tower
visible for miles around,
date back to the 13th
century. One of the*

*church's more unusual
features are the 16th-
century stables, among
the oldest in Sweden,
where churchgoers
tethered their horses
during services.*

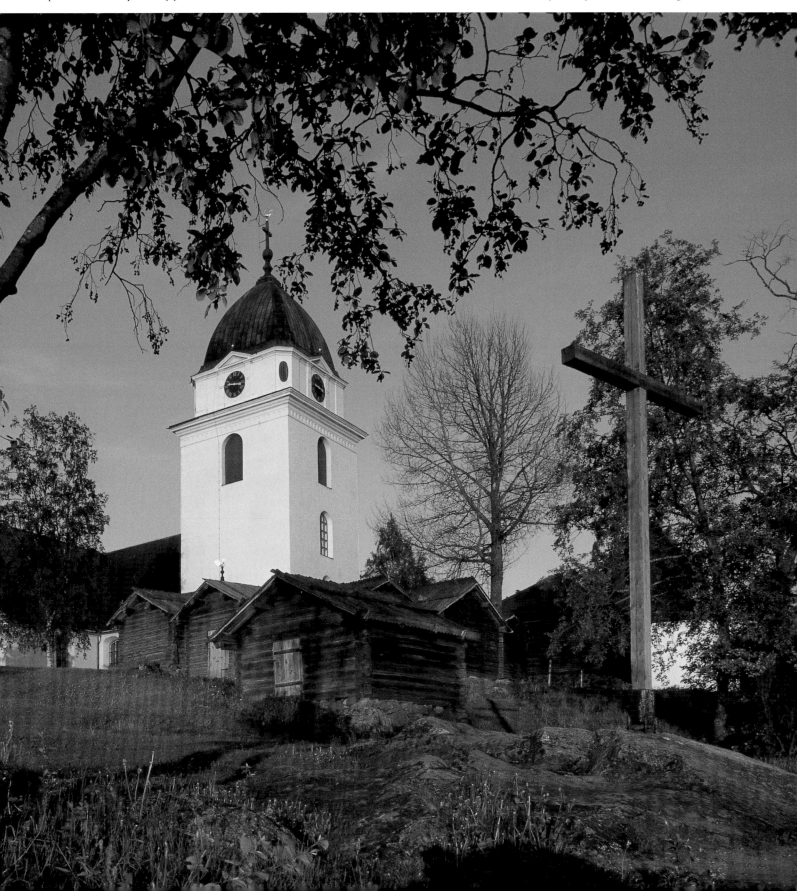

FESTIVALS

The Swedes have always got an excuse to party; apart from the usual Christmas, Easter and Whitsun holidays, they have an entire calendar of special feast days not celebrated by their more southerly cousins. After the passing of the long, cold winter, the arrival of spring, for example, is as good a reason as any for a knees-up. On April 30, Valborg or Walpurgis Night, bonfires are lit, bangers and rockets let off and canons fired to drive away the evil spirits, with some towns even putting on a special fireworks display. This festival is particularly popular with students both young and old – and not just for the obligatory consumption of large quantities of alcohol. In Uppsala especially they prance through the streets in traditional white caps and – hangovers permitting – often join in political rallies the next day, May 1 being not just a public holiday but also a traditional day for demonstrations.

DANCING ROUND THE MAYPOLE ON MIDSUMMER'S DAY

In a country not exactly blessed with giddy levels of sunshine the summer solstice is an important occasion. Midsommar, the festival of the shortest night and the longest day, is the absolute highlight of the year, celebrated at length the weekend following June 21. Churches and houses are draped in garlands of flowers and special maypoles or »majstång«

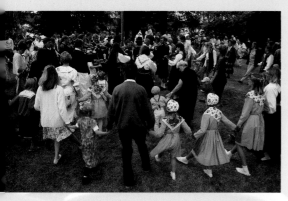

are erected, crosses decorated with branches of birch and floral wreaths. The maypole is usually put up by the men of the village on Midsummer's Eve, the Friday of the festival weekend, to the accompaniment of local musicians, an occasion which not infrequent-

ly turns into a party. Once in place, people dance the night away around the maypole to the traditional tune of fiddles and accordions, the children with flowers in their hair and often in local costume, especially out in the country. Midsommar is at its most original in Dalarna in the heart of Sweden.

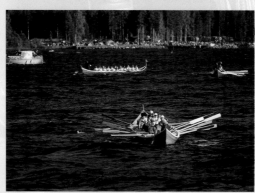

»KRÄFTOR« AND »NUBBEVISA«

The second half of August provides Swedes with a good culinary reason for getting together with friends and relatives. Mid-August heralds the opening of the crab season. Depending on location and finances the people of Sweden simmer either expensive freshwater crabs (insjökräftor) or the cheaper saltwater variety (kräftor) in a dill stock which they then serve with potatoes. Sounds like a fairly normal undertaking – if you don't count the glasses of schnapps or »nubbar« between courses. Crab dinners follow a strict pattern. First people eat, then they sing a »nubbevisa« or drinking song and finally wash it all down with a glass of something powerful. The whole procedure is then repeated – several times. Party hats are often worn, the festivities getting merrier and merrier with each »nubbevisa«, especially if not all the guests are practised in the art of crab consumption and only manage to imbibe tiny morsels in the short breaks for food between rounds.

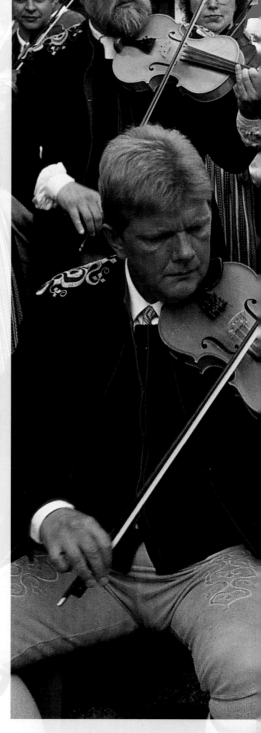

Far left:
Midsummer wouldn't be Midsummer without the traditional dancing round the maypole (majstång), a grand occasion for young and old.

Left:
At Midsummer local church races are held on Lake Siljan in Dalarna, where teams in long, heavy rowing boats compete to see who can cross the water the fastest. Th church boats were once

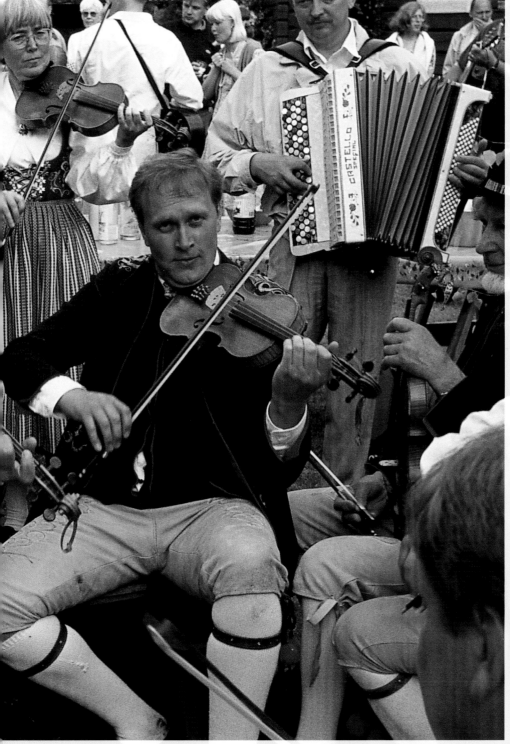

LUCIAMORGON

With summer gone and winter howling at the doorstep the pace slows down somewhat. December 13 is St Lucia's Day or the festival of light, designed to bring hope to the long, dark Swedish winter. St Lucia was a medieval martyr from Sicily; in the north she is interpreted as the bringer of light (lux) and the symbol of the return of the sun. Clad in a white gown with a crown of candles on her head, Lucia is accompanied by an entourage of followers in white bringing light into the darkness, particularly in kindergarten, schools and local communities. The morning of St Lucia begins with special songs, saffron biscuits (Luciakatten) and coffee or sometimes mulled wine by candlelight. Even though an official Lucia parade is broadcast from Stockholm, giving the proceedings a somewhat commercial touch, this particular feast day is more of a peaceful occasion where the focus of attention is on the children taking part in the procession.

At the celebration of the summer solstice women and girls often wear local costume and wreaths of flowers in their hair.

Above:
Midsummer in Leksand on Lake Siljan is a traditional affair, with old Swedish folk music, dancing and local costume.

Тhe best way of reaching сhurches dotted out the lakeside, the urney on horseback lling for long detours.

Top right:
On Luciamorgon on December 13 all little girls want to be Lucia, with a halo of light in their hair to illuminate their way through the night. Local processions can thus feature several Lucias and a comparatively small number of »tärna« or accompanying maidens. Boys can join the entourage, too, as »stjärngossar« or star boys.

Below:
Strolling through the centre of Uppsala, you hardly notice that you're in the fourth-largest city in Sweden. The architecture and atmosphere here effuse the peaceful charm you would expect of an old university town. Founded in 1477, the university itself was the most northerly seat of learning in Europe.

Right:
The magnificent Gothic cathedral of Uppsala, which dominates the city's silhouette, is the final resting place of many famous Swedes, one of them Carl von Linné or Carolus Linnaeus. It was also where Sweden's kings were crowned between 1140 and 1719.

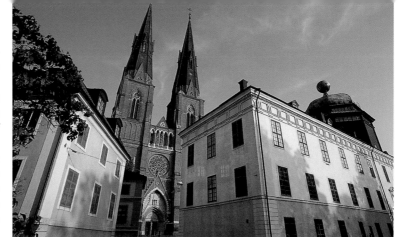

Top right:
The castle in Uppsala perches atop a hill above the city. Rebuilt after a fire in 1757, it seems more stronghold than palatial residence. The imperial hall in the castle where Queen Christina took her leave from politics after converting to Catholicism.

Centre right:
A number of lush parks invite you to take a break from sightseeing in Uppsala. Among the most interesting are perhaps the Botanical Gardens with over 10,000 different species of plant and Carl von Linné's marvellous landscaped creation.

Bottom right:
The 17th-century house where the famous botanist Carl von Linné once lived is situated in his reconstructed garden where the plants are arranged according to the system of classification Linné devised.

81

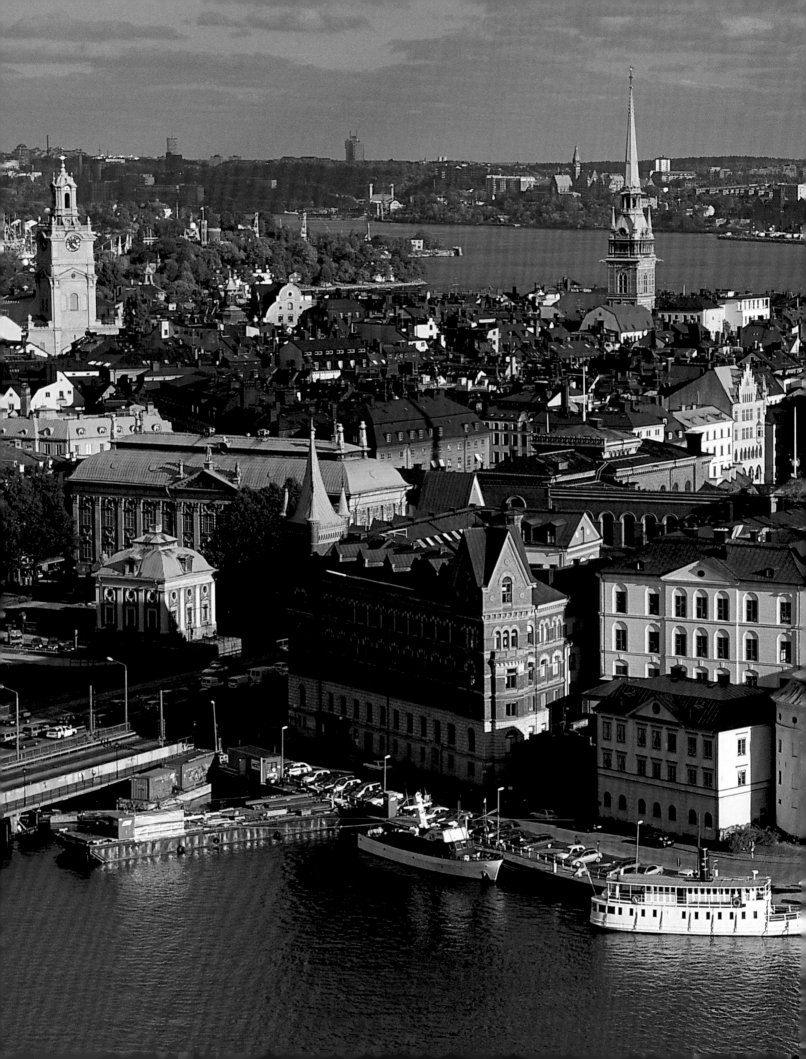

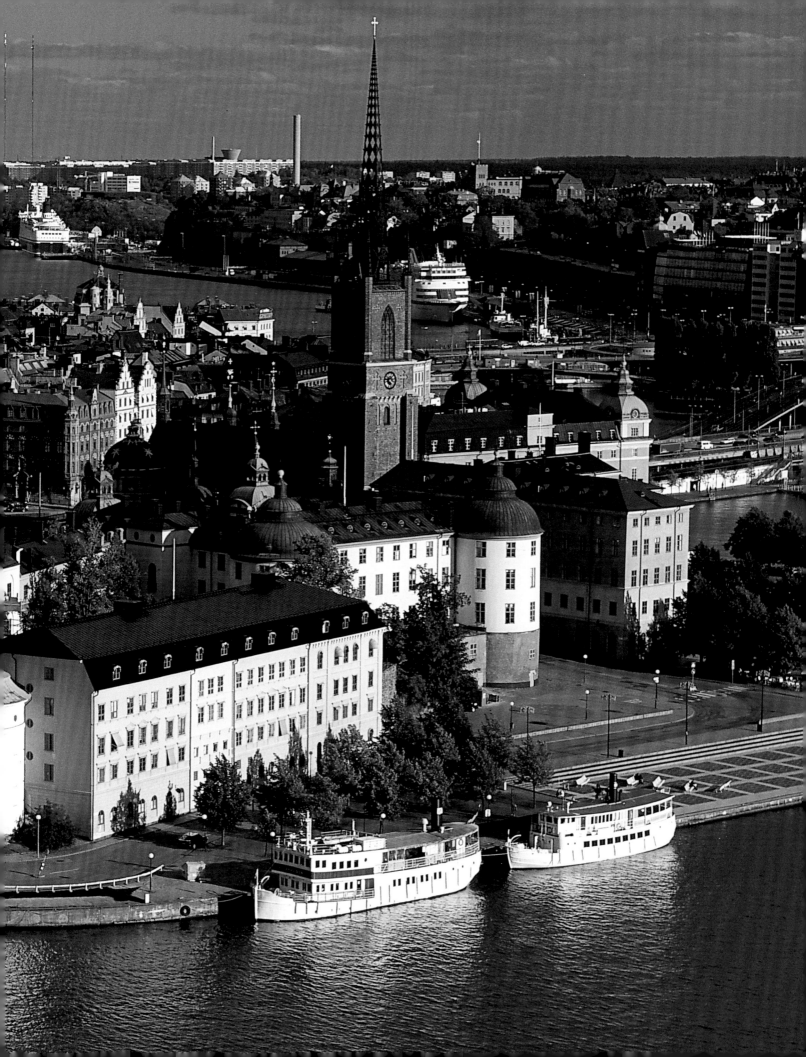

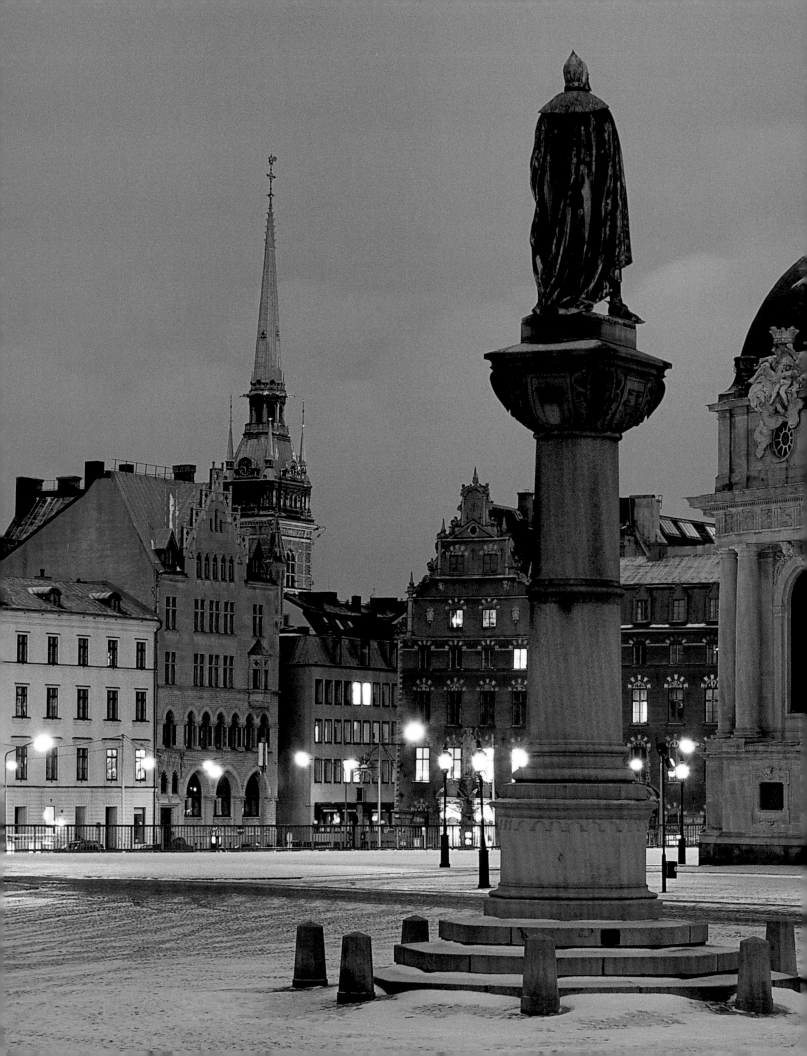

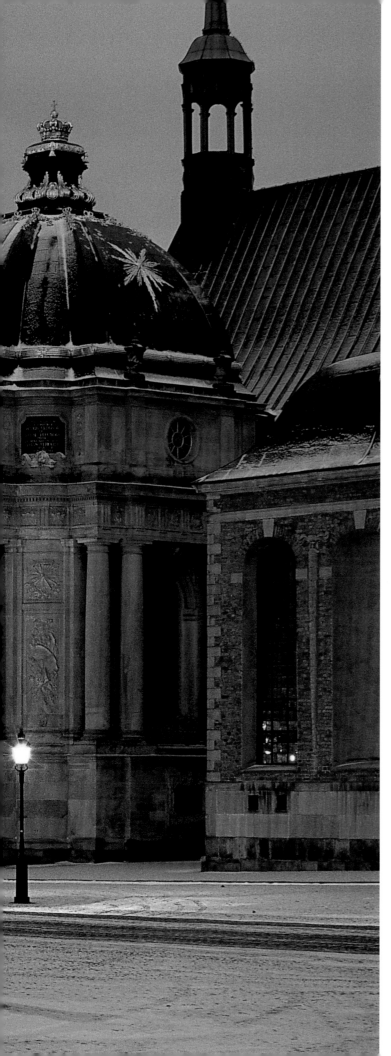

Left:
Birger Jarls Square on Riddarholmen Island in Stockholm is named after the head of the Folkunger dynasty who ruled over the Swedes from the mid-13th to the mid-14th centuries. Birger Jarl founded both the city and castle of Stockholm.

Below:
The morning light catches the roofs of Stockholm's Södermalm district hugging the southern shores of Lake Mälaren. Numerous cafés, pubs and art galleries line the narrow streets of the hillside town, more than making up for Södermalm's comparative lack of tourist attractions.

Page 82/83:
Surrounded entirely by water, Sweden's capital city Stockholm bridges 14 islands dotted about the Mälaren estuary. The old town islands of the »Venice of the North«, Gamla Stan, are particularly scenic.

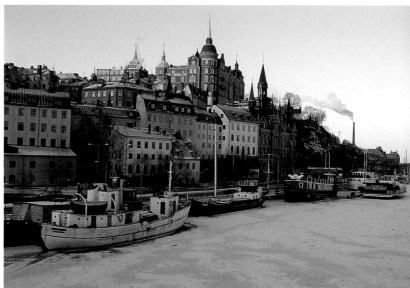

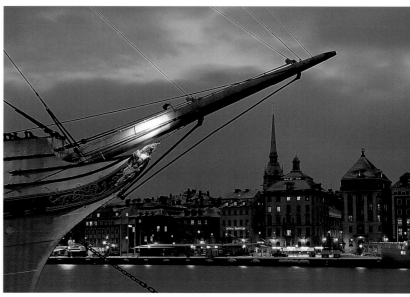

Above:
Like Venice, both water and boats are omnipresent in Stockholm. The bright lights of Riddar-holmen twinkle in the night sky, perforated by the neo-Gothic, cast-iron tower of Riddarholmen's parish church.

Below:
In winter the streets of Gamla Stan on the island of Stadsholmen are quiet and tranquil. Although built according to the

medieval street plan, the present houses are from the 17th century, built in stone to reduce the risk of fire.

Top right:
The harbour on Skeppsholmen, the island adjoining Stockholm's Gamla Stan, is firmly in the grip of winter. All

year round it's worth visiting for the museums of modern art and architecture and its fantastic scenery alone.

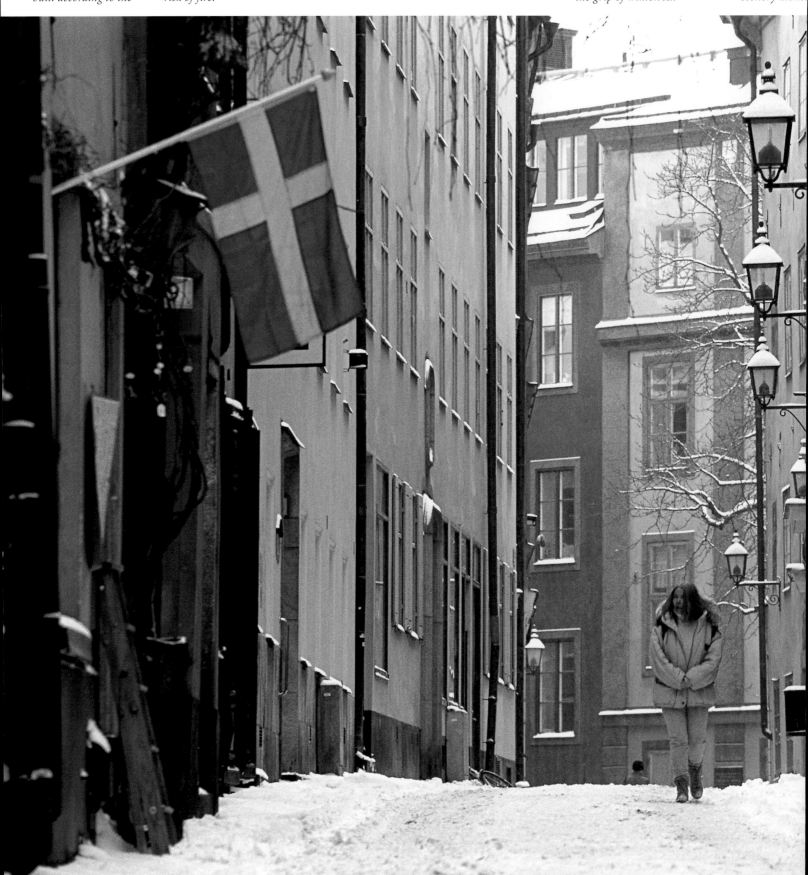

Centre right:
The streets of Gamla Stan have retained much of their medieval character. In the 12th century this is where German traders from Lübeck came to sell iron to the Swedes.

Bottom right:
Skeppsholmen has art, nature and art in nature. Here a group of sculptures by Niki de Saint Phalle and Jean Tinguely outside the Museum of Modern Art.

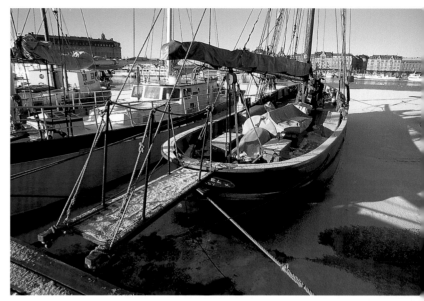

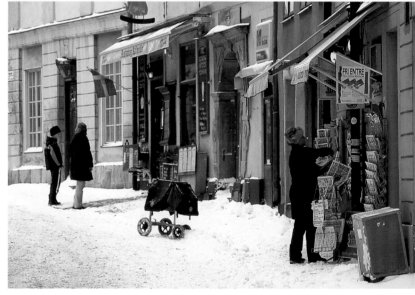

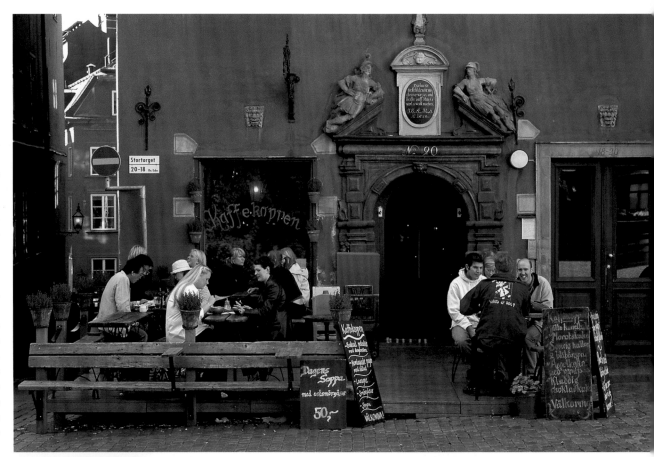

Right:
The main square in
Stockholm's Gamla Stan is
Stortorget (»big square«),
surrounded by elegant
town houses. Used as a
market place in the
Middle Ages, tiny streets
and alleyways still split
off from the square in
all directions.

Below:
Riddarholmen's church
on Birger Jarls Torg was
built in 1280 by the
Franciscans as a mona-
stery church. Used as the
chief burial place for
Swedish royalty, over the
centuries it has become
cluttered with numerous
tombs and chapels of rest.

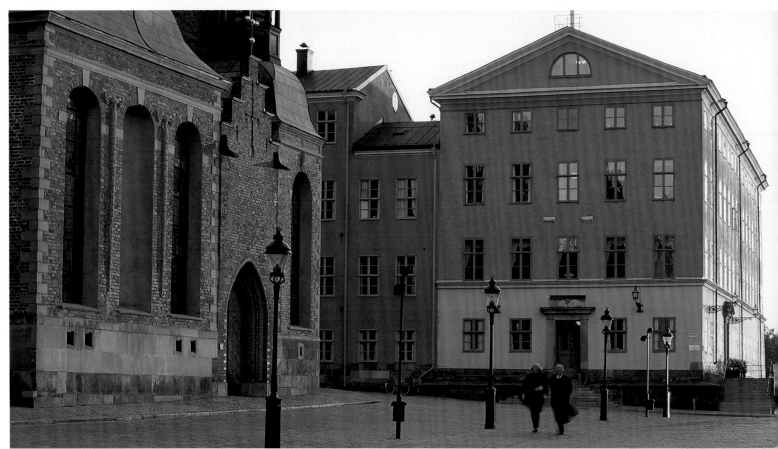

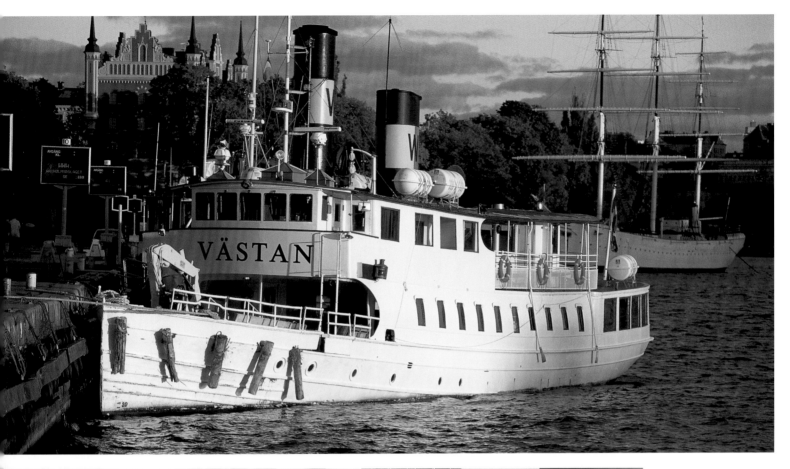

Above:
When in Stockholm a trip aboard one of the city's romantic white steamers past the 24,000 islands and skerries of the archipelago is an absolute must.

Left:
Relaxing quietly outside one of the cafés on Stortorget in Gamla Stan today, it seems almost impossible that in 1520 this is where the Stockholm Bloodbath took place, leading to the end of the Kalmar Union of Denmark, Norway and Sweden.

Left:
This Nobel Prize certificate was awarded to Emil von Behring in 1901 by the Karolinska Medikokirurgiska Institutet which still decides on the recipient of the Nobel Prize for Medicine.

Below:
Each December 10, the day of Alfred Nobel's death, the Blue Hall at the Stadshuset (town hall) in Stockholm is the elegant setting for the

presentation of the year' prizes by the royal couple The Stadshuset was buil between 1911 and 1923 by architect Ragnar Öst-berg in the national romantic style.

The chemist and great inventor Alfred Nobel was born in 1833 and died on December 10 1896. In his last will and testament he specified that the bulk of his fortune be invested in a fund, »the interest from which shall be given as a prize to those who over the past year have done great service to mankind«.

Since 1901 Nobel Prizes have been awarded for physics, chemistry or physiology, medicine and literature and also to the person »who has done the most or performed the best services for the alliance of the peoples of the world, for the abolition or reduction of existing armies and for the instigation or spreading of peace«. The first four prizes are bestowed by Swedish organisations; the Nobel Prize for Literature is presented by the Swedish Academy, founded in 1786, whose 18 members closely monitor the development of Sweden's language, literature and rhetoric, the medicine prize by the Karolinska Institute and those for physics and chemistry by the Swedish Academy of the Sciences. The allocation of the Nobel Prize for Peace is decided by a special committee acting on behalf of the Norwegian parliament in Oslo. As the Swedish-Norwegian Union was still in effect while Alfred Nobel was alive, it was decided that at least one prize should be conferred in Norway. The list of accolades was added to in 1968 when the National Bank of Sweden introduced the Nobel Prize for Economics.

ALFRED NOBEL, A »SORRY CREATURE«

By endowing prizes in his name, Alfred Nobel became famous worldwide. It seems strange, however, that the father of Sweden's armaments industry and the

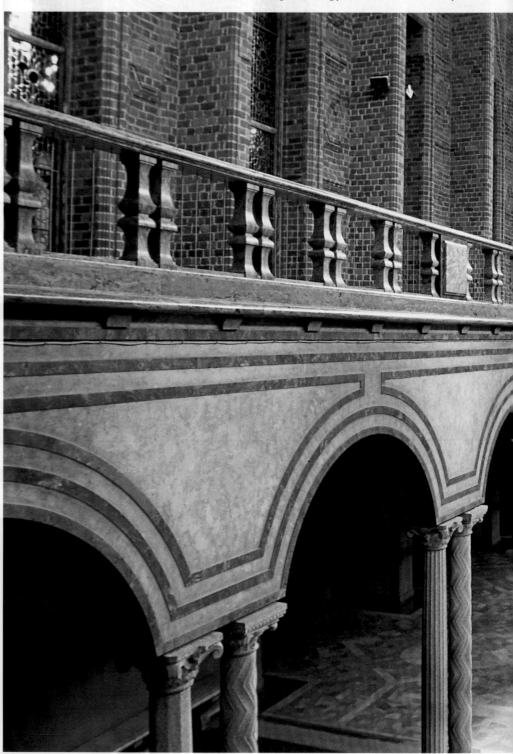

Curiously, the founder of the Nobel Prize, Alfred Nobel, was also the father of Sweden's armaments industry. He bequeathed to the world not only his famous prizes but also 350 patents, his most famous invention being dynamite.

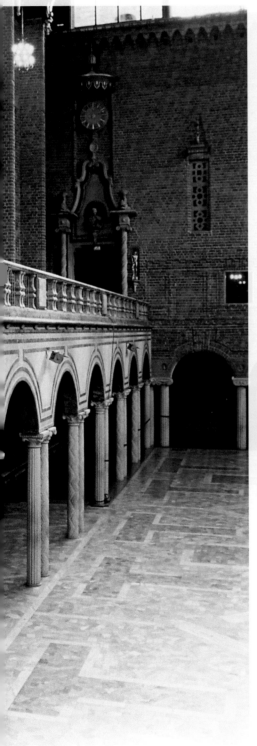

inventor of dynamite should have bequeathed a prize for peace. His success (he owned 90 factories and businesses in over 20 countries) was marred by inconsistency and personal insecurity. This is clearly documented in the brief description he gives of his life: »Alfred Nobel, that sorry creature, should have been suffocated by a well-meaning doctor upon his entry into this world. Major achievements: he keeps his nails clean and does not burden society. Major faults: no family, flippant and a glutton. His greatest and sole request: not to be burnt alive. Gravest sin: does not pray to Mammon. Major events in his life: none.«

Alfred Nobel never married, didn't get the woman he wanted, Countess Kinsky, later Bertha von Suttner, and made himself a laughing stock through his 18-year-long obsession with a girl 23 years younger than himself. It is thought, however, that his life-long friendship with Bertha von Suttner, a champion of the peace movement, was the reason for his funding a prize for peace. Bertha von Suttner herself was awarded this very prize in 1905.

A LIST OF GREAT NAMES

Not only Alfred Nobel achieved world fame with his prizes. If you take a look at the list of those invited to Stockholm since the initiation of the award many, if not all, of the great names of the last two centuries are included: Theodor Mommsen, Wilhelm Conrad Röntgen, Selma Lagerlöf, Marie Curie, Maurice Maeterlinck, Max Planck, Gerhard Hauptmann, Robert Koch and Thomas Mann. Most of the prize-winners have received their awards on the merit of their great inventions or literary offerings, often as a final honour in celebration of their life's work. Alfred Nobel had something else in mind; he wanted to »help the dreamers who have a particularly difficult time in life«. Despite this even 100 years on from the birth of this Swedish institution prize nominations, and especially those for literature, are still the subject of great public interest and – not infrequently – heated discussion.

The award ceremony itself takes place in Stockholm on the day of Alfred Nobel's death and is presided over by the king, who personally presents the prizes to the year's

winners. After the ceremony an official banquet is held at the Stadshuset in Stockholm. This prestigious event, with delicacies served on special Nobel Prize china, is so popular in Sweden that it is broadcast on TV.

Nelly Sachs, the German writer who emigrated to Sweden in 1940, used the money from her 1966 prize to help needy friends who had assisted her during her years of poverty and suffering in Germany and Sweden.

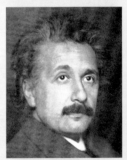

Possibly the most famous prize-winner of all is Albert Einstein, awarded the Nobel Prize for Physics in 1921.

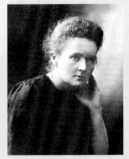

Marie Curie was the first and at 36 also the youngest woman to win a Nobel Prize in 1903 in the male domain of science. She is also unique in that she was awarded the prize again in 1911.

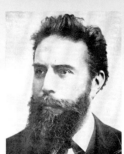

At the first award ceremony in 1901 Wilhelm Conrad Röntgen was honoured for his discovery of the X-ray.

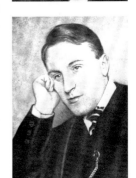

Carl von Ossietzky, journalist and pacifist, won the Nobel Prize for Peace in 1935, prompting Adolf Hitler to immediately ban Germans of the Reich from accepting the award.

Below:
With the changing of the guard (bottom) and concerts given by the military band (below left), the soldiers of the Swedish Royal Guard are often a bigger crowd-puller than the palace itself, situated on the north flank of Stadsholmen Island. When the old Vasa castle Tre Kronor burnt down in 1697 Carl Hårleman and Nicodemus Tessin the Younger began work on the present replacement, which wasn't finished until 1770. The royal family only stays here on state visits, their permanent place of residence being Drottningholm Palace on the edge of the capital.

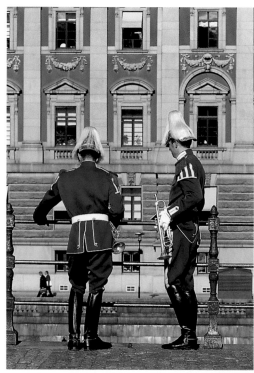
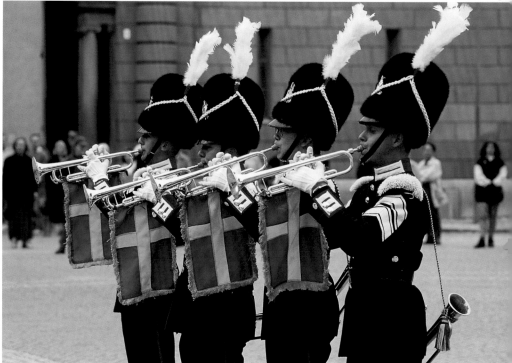
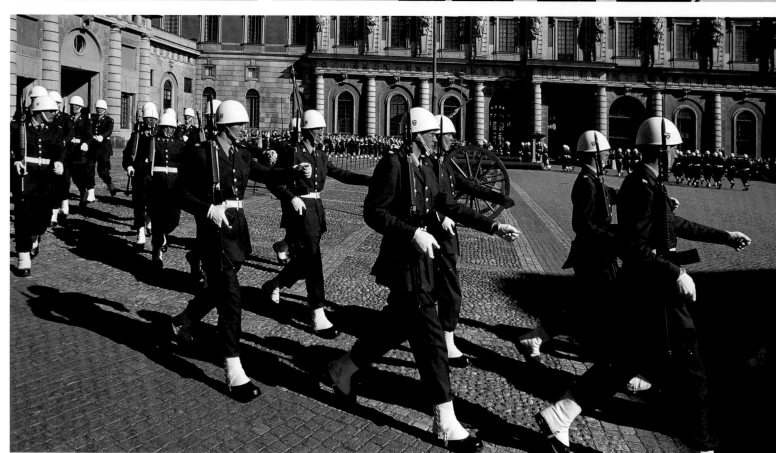

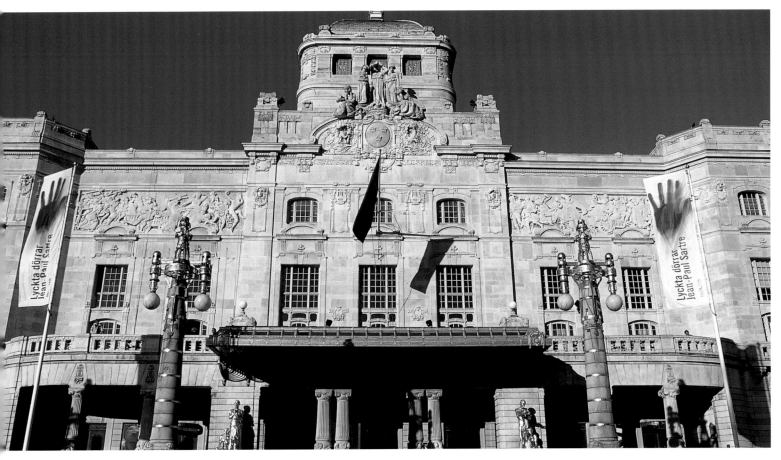

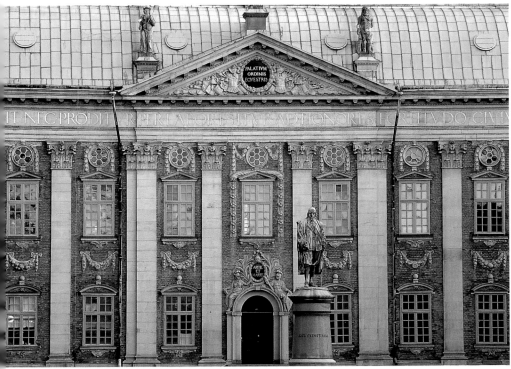

bove:
he Riddarshuset or
ouse of nobles on
adsholmen was built
tween 1641 and 1674

by Justus Vingboons and
Jean de la Vallée in
restrained Baroque for
meetings of the Swedish
nobility.

Above:
The official buildings of
Gamla Stan on
Stadsholmen are not the
only ones to disseminate

a sense of purpose and
importance. Some of the
private houses are just
as prestigious in their
architecture.

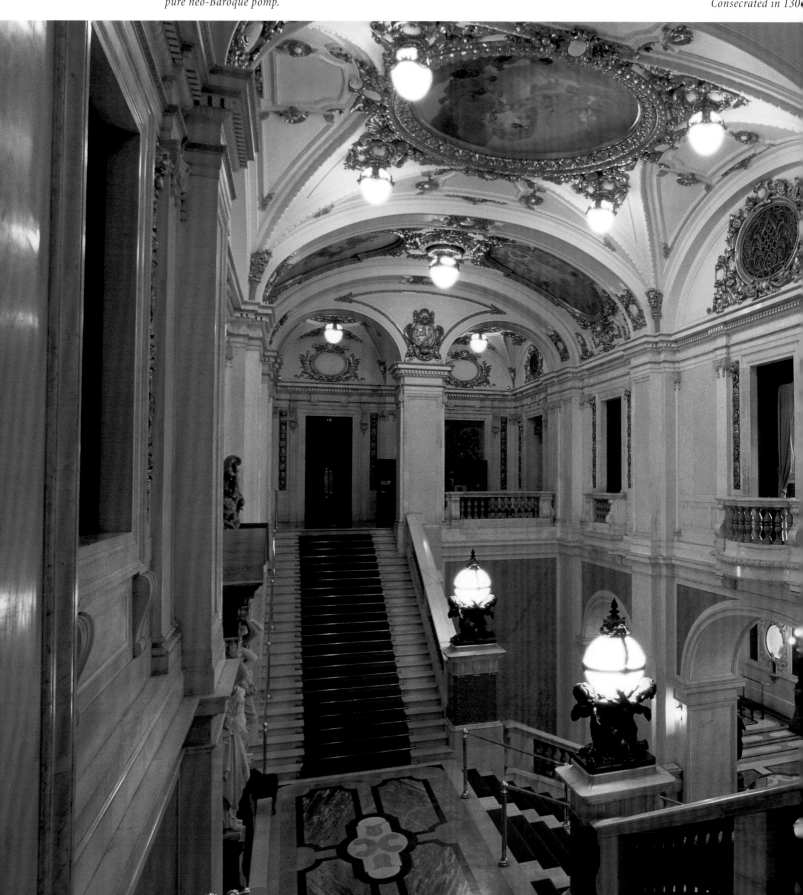

Below:
The opera house on Karl XII Square, constructed between 1891 and 1896 to replace its predecessor, where Gustav III was shot at a masked ball, is pure neo-Baroque pomp.

Top righ
Storkyrkan is Stockholm cathedral and coronatio church, late Gothic o the inside and Baroqu on the outsid Consecrated in 130

Centre right:
The Golden Hall of Stockholm's town hall was fashioned by Einar Forseth who used no less than two million golden mosaic tiles for his masterpiece.

Bottom right:
Once you've got through the usual evening queues outside Sweden's venues of renown the legendary Café Opera is the ideal place to people watch.

it is one of the oldest buildings in Stockholm, despite its many phases of refurbishment.

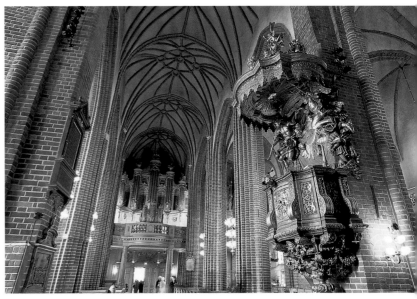

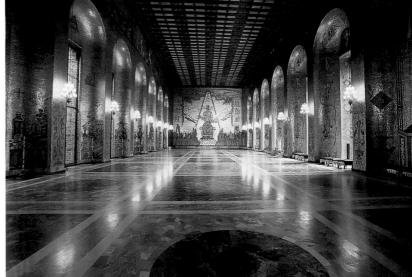

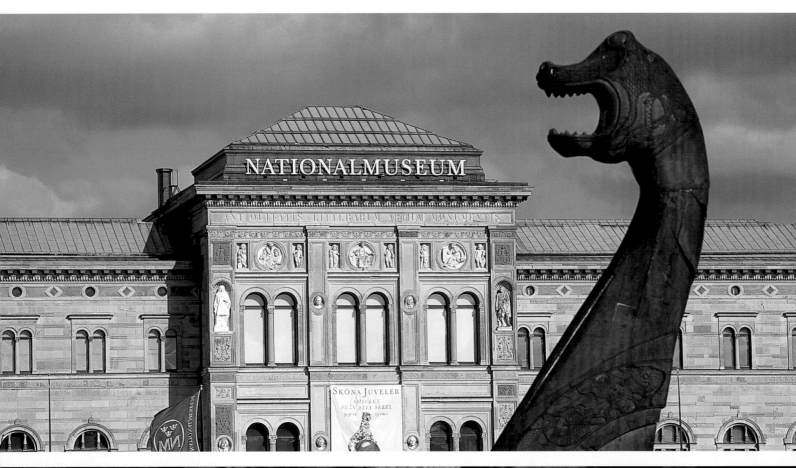

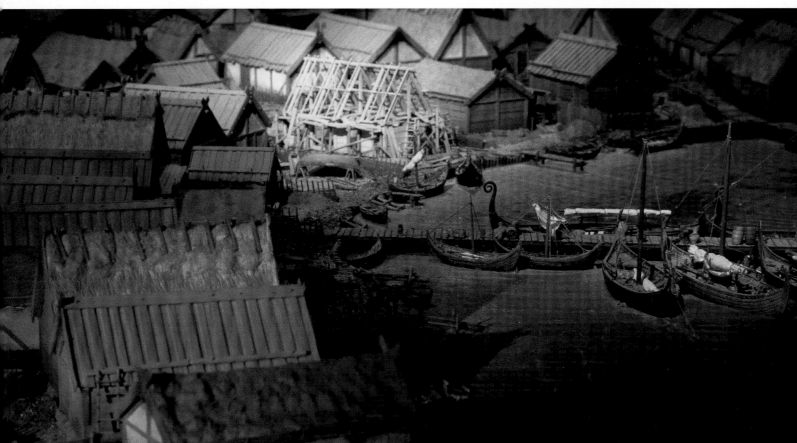

Left:
The neo-Renaissance
National Museum in
Stockholm was designed
by the architect who
built the New Museum in
Berlin, Friedrich August
Stüler. The international
collection includes works
by classic Swedish artists
and also by Dutch and
French painters.

Below:
The Vasa Museum on
Djurgården Island has
just one, unique exhibit:
Gustav II Adolf's regal
warship. It sank in
Stockholm harbour on
its maiden voyage in 1628
where it was recovered
with all its paraphernalia
in 1961 and subse-
quently restored.

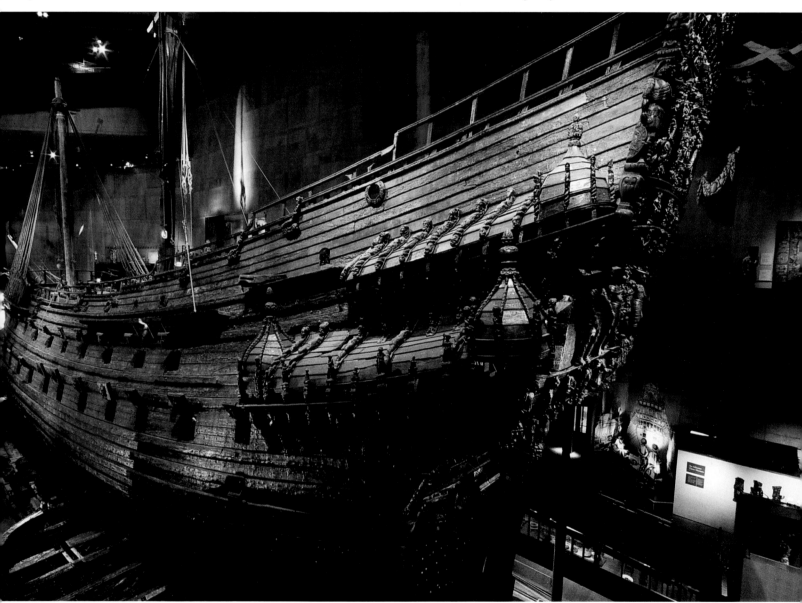

Left:
In the 9th and 10th
centuries the island of
Björkö (»birch island«)
in Lake Mälaren was an
important centre of trade.

The Birkamuseet has a
model of the old Viking
settlement and describes
what life was like during
the Viking period.

Top left:
The founder of Sweden's oldest open-air museum Skansen, Artur Hazelius, reconstructed buildings from all over the country on the island of Djurgården.

Centre left:
The colourful wooden houses on Stora Gata in Sigtuna on Lake Mälaren allegedly make up the oldest street of shops in Sweden.

Bottom left:
Old-fashioned little coffee shops like Aunt Brun's are what make Sigtuna the charming little town it is today. Founded in 970, Sigtuna is the oldest

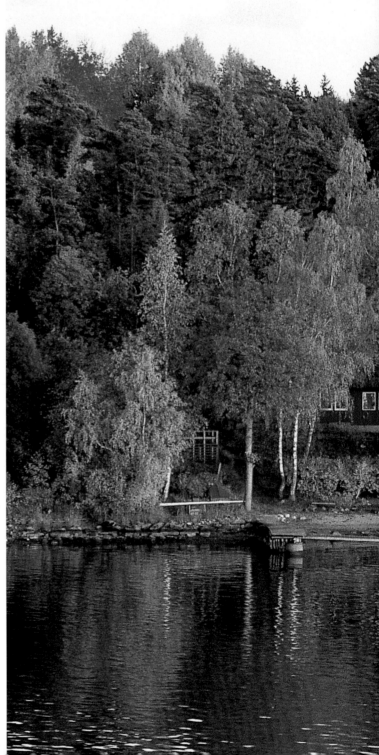

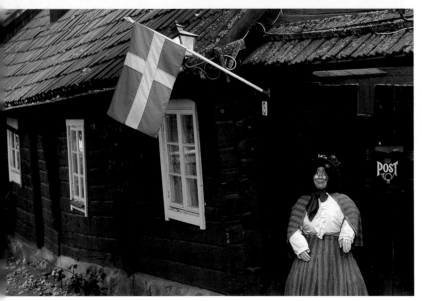

98

own in Sweden and was
nce an important
entre of activity before
was overshadowed
y the big cities of
tockholm and Uppsala.

Below:
*The brilliant colours of
the Swedish forest illu-
minate the skerries in
autumn, just a stone's
throw from the hustle and
bustle of Stockholm.*

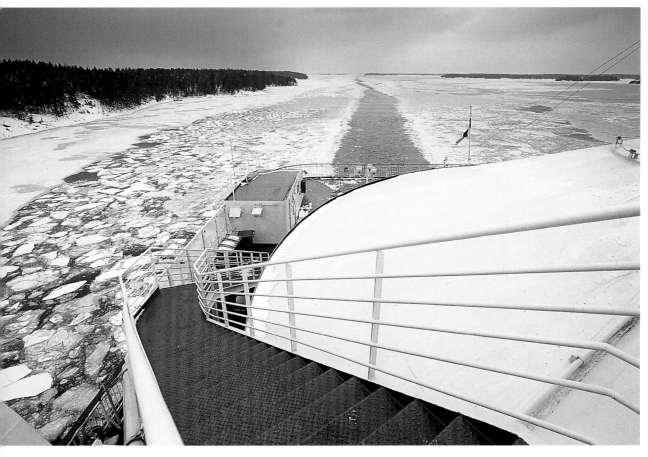

Even in the frozen winter months – which in snow are not as dark as you might think – the waterways of Stockholm's archipelago are still used. The Mälaren estuary with its thousands of islands and islets, skerries and bays provides Stockholm with the perfect harbour which in winter is kept clear by icebreakers.

Jämtland in the north of Sweden is covered with spruce forest, interspersed with river valleys and sprawling lakeland districts. At Handöl the highest riverine waterfall crashes down into the depths of the wooded valley.

With a surface area of 260,500 square kilometres (ca. 100,580 square miles) Norrland or northern Sweden covers 60% of the country and is crossed by nine degrees of latitude, with the Arctic Circle running just north of its centre. Sweden's highest mountain, the Kebnekaise, the most northerly destination of Nils Holgersson and his wild geese, towers up above the silent wastes of the north. The most southerly provinces, Gästrikland and Hälsingland, are two separate historical entities now joined together as a »län« or administrative district governed from the provincial capital of Gävle. The 430 kilometres (267 miles) of Ljusnan River link Hälsingland to Härjedalen which extends as far as the mountains along the Norwegian coast. The region is marked by stretches of impenetrable forest, treeless mountain summits, moorland, water and Sweden's southernmost glacier.

The most northerly rune stone in Sweden stands in Jämtland whose mountains make it popular with skiers. The name of the neighbouring province, Medelpad or »middle path«, possibly refers to the ancient pilgrim's way leading through lonely, wooded mountains, which reach almost to the sea, to the grave of St Olof at Nidaros, now Trondheim in Norway. Ångermanland is 80% forest; small wonder, then, that industry here centres almost entirely on wood. Västerbotten also has a wood connection; Ivar Kreuger was »the King of Matches« here. Norbotten bordering on Finland and Lapland, with the Arctic Circle running through both, make up the northernmost tip of Norrland. This is where the Land of the Midnight Sun begins.

The largest province in the north is Lapland, a wildly romantic world inhabited by the Sami and their reindeer. With its riverine valleys, lakes, waterfalls and Sweden's highest peaks, this is a mountainous region bursting with natural spectacle. It also has the largest concentration of iron ore, with much of the mining activity focussing on Kiruna.

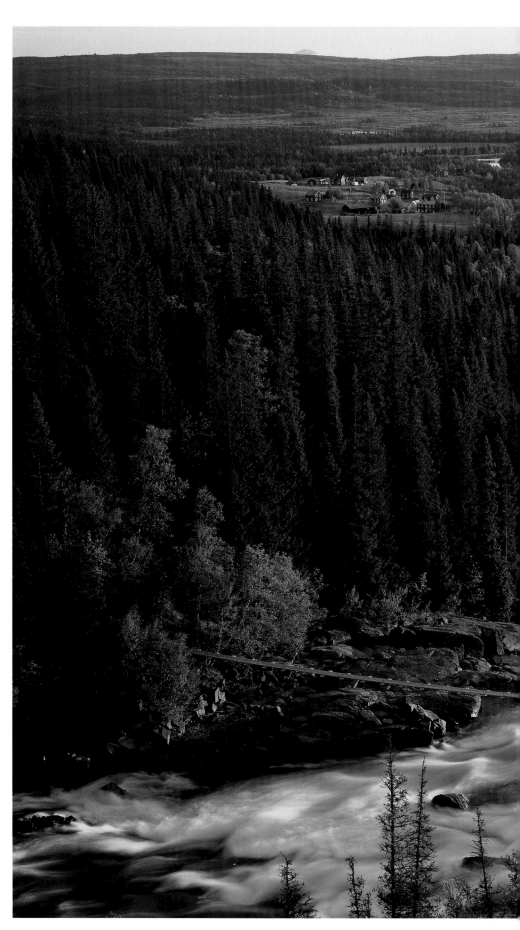

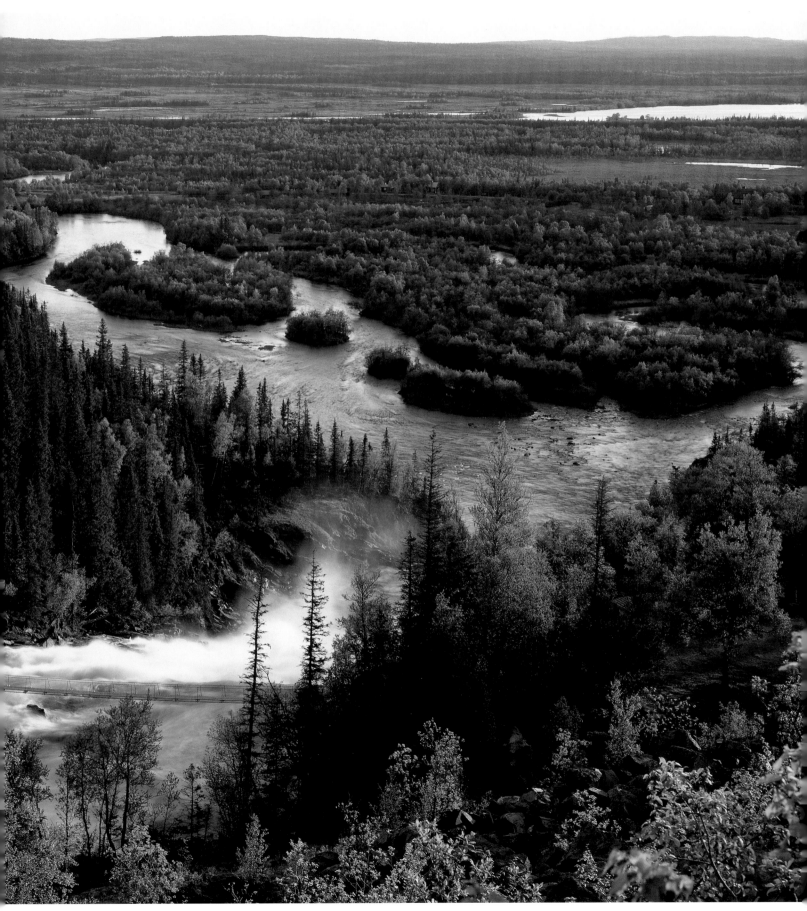

Below:
Some of the wonderful wooden houses in the old town of Gävle date back to the 18th century. Gävle is the provincial capital of Gästrikland and the oldest town in Norrland.

Right:
The renovated 17th-century church chalets in Lövånger, Västerbotten, provided accommodation for churchgoers who had often travelled far to attend services.

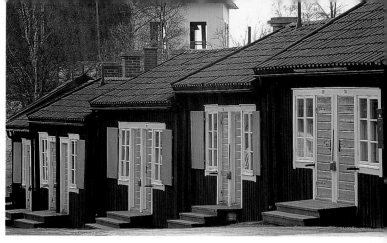

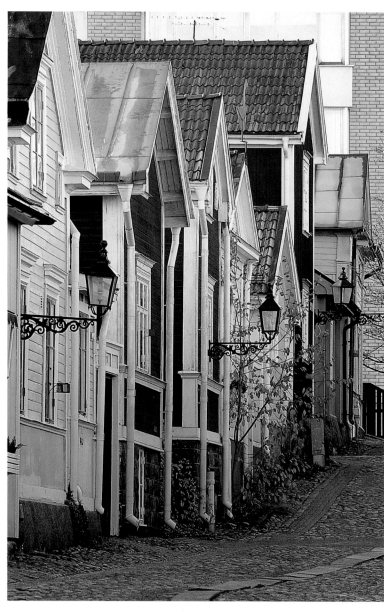

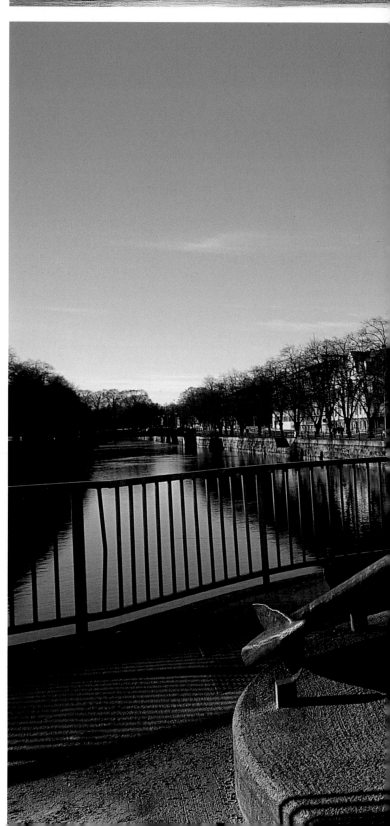

Right:
Gävle is the second-largest coastal resort north of Stockholm and was established in 1446. Its busy harbour made it an important centre of trade and travel.

Left:
*The Bruks Industrial
Museum outside
Hudiksvall is dedicated
to the iron industry
although the Norrland's
second-oldest town
initially became known
for its wood.*

Below:
*From this farm dwelling
near Mattmar there is
an excellent view of the
bleak mountains of
Jämtland which in
winter provide fantastic
skiing conditions.*

Top right
*Several miles east o
Duved in Jämtland on
of Sweden's highest an
most impressive water
falls, Tännforsen, tumble
38 metres (125 feet
down to the valley floo*

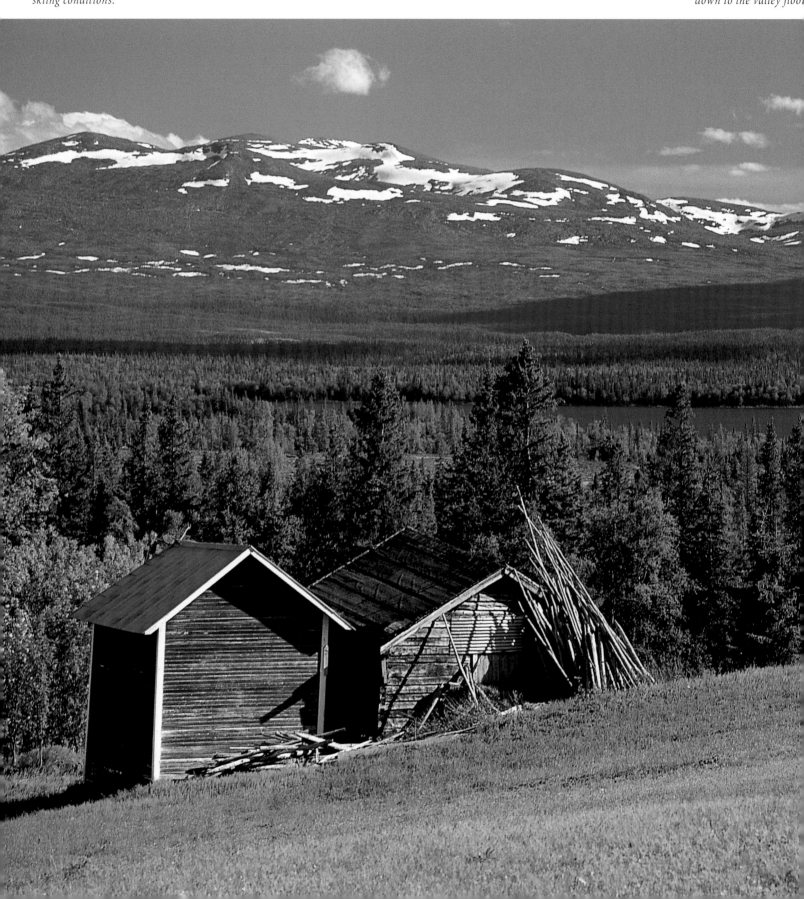

Page 108/109:
One of Jämtland's spectacular waterfalls is the Ristavallet, here captured in the light of the midnight sun at 11 pm.

Centre right:
The lakes of Jämtland are calm and serene; here Lake Hotagen.

Bottom right:
The rock carvings near Glösa in Jämtland depict numerous animals.

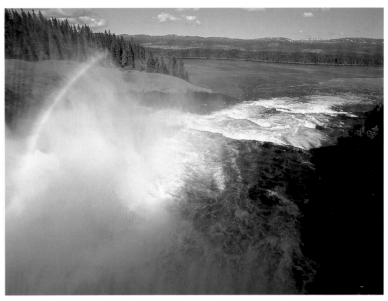

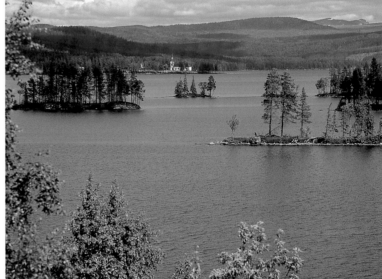

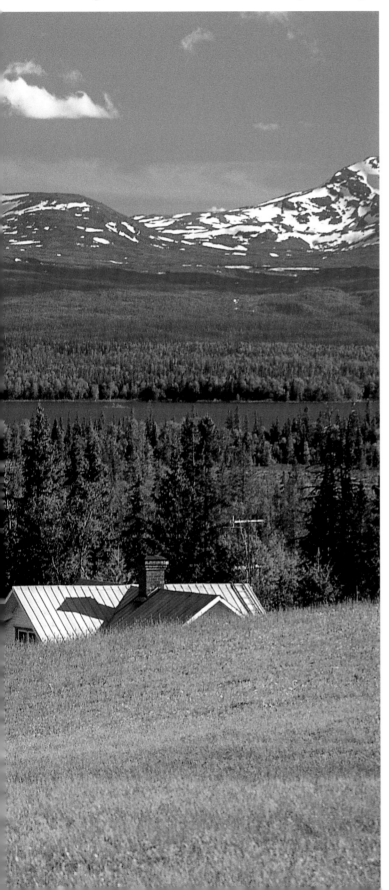

107

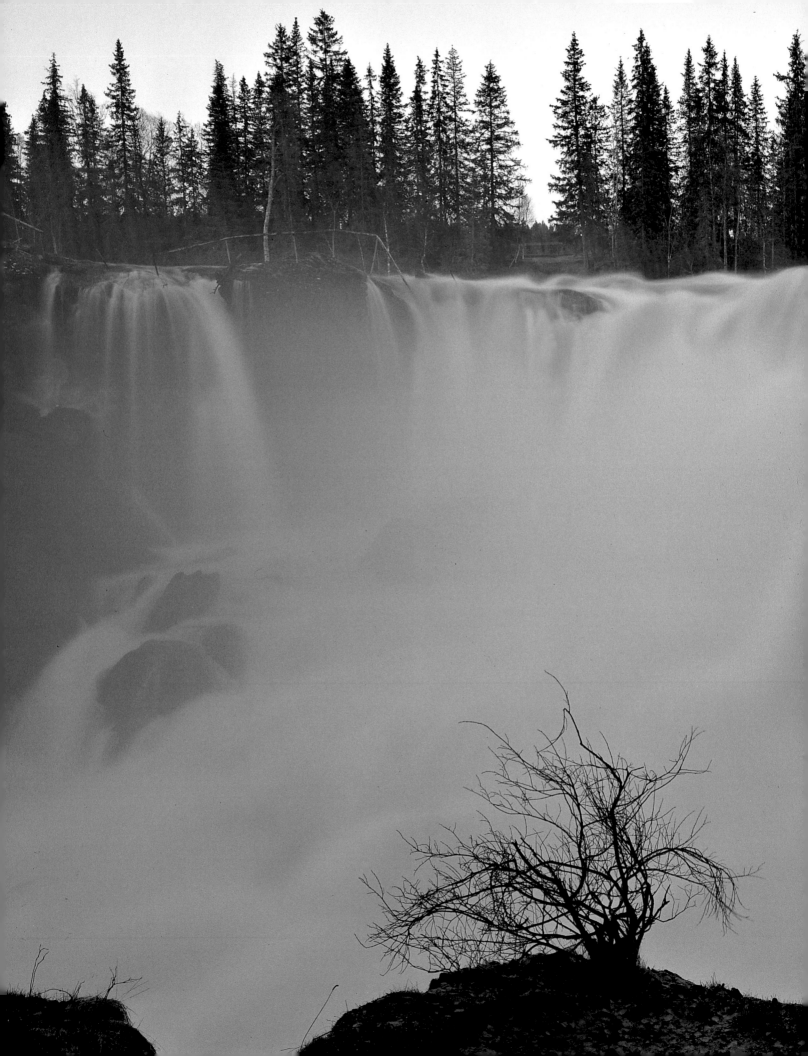

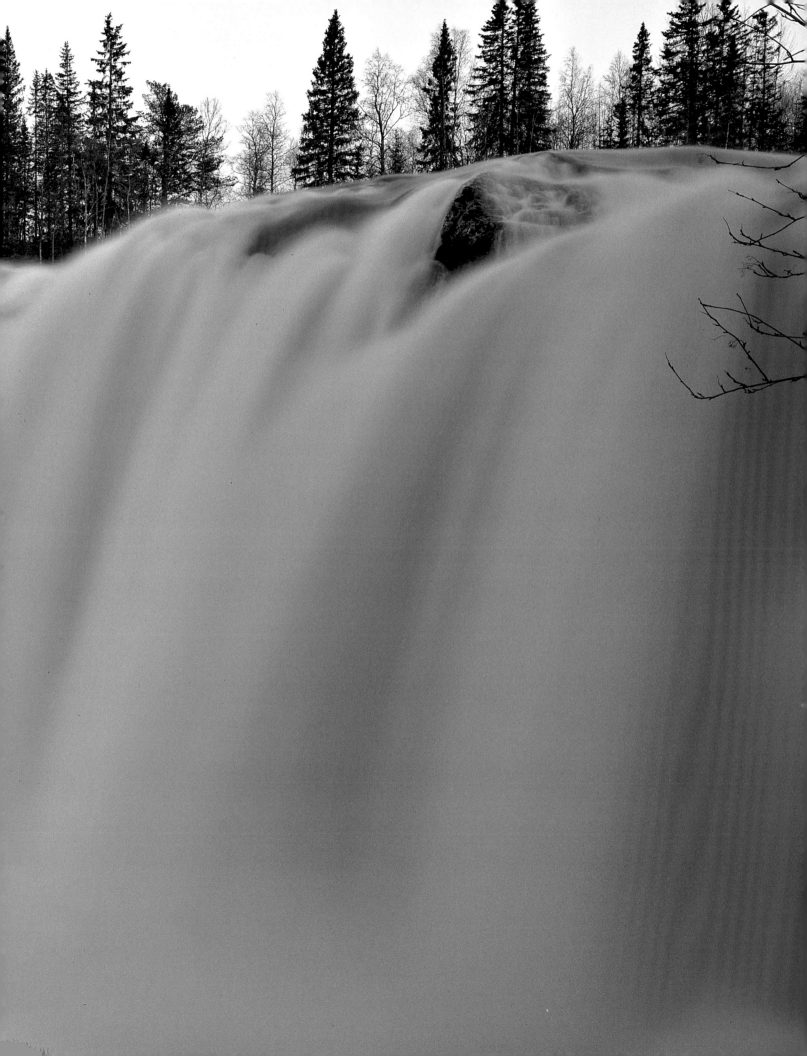

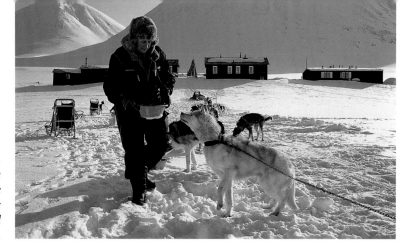

Below and right:
The Kungsleden (king's path), one of the most popular trails through the north of Sweden, starts in Abisko and ends 500 kilometres (310 miles) further south in Hemavan. In summer hikers take in the expanse and solitude of the wastes of the north; in winter the trail is used by teams of huskies.

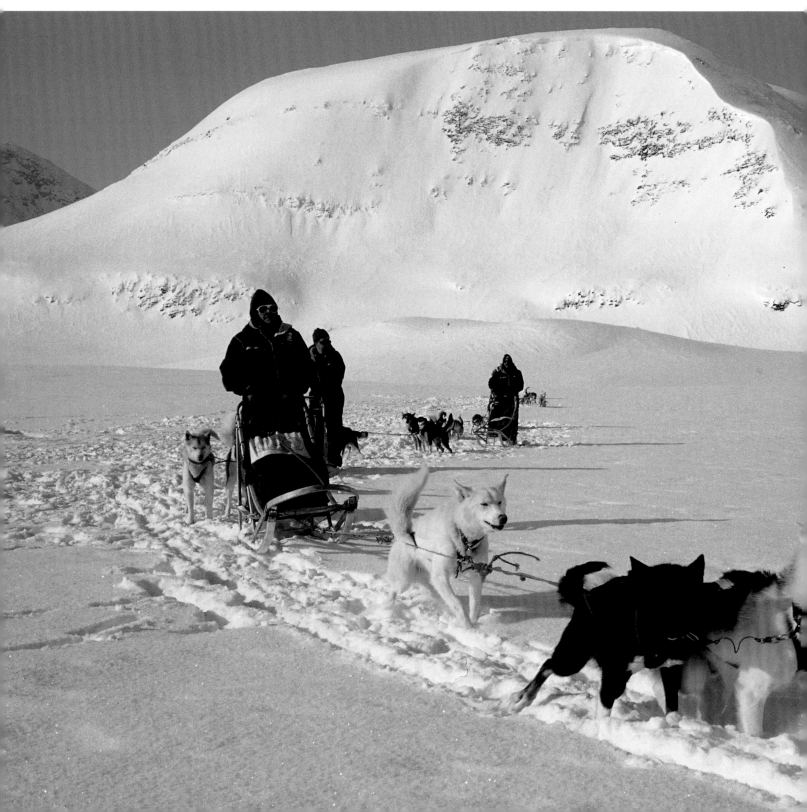

Top and centre right:
The lonely heights of the Kungsleden can also be explored on skis. Winter cross-country skiing conditions in northern

Sweden are usually excellent, making a trek across the frozen snow-fields an unforgettable experience.

Bottom right:
Evenings can be spent relaxing at the Sälka mountain hut on the Kungsleden after a hard day's skiing.

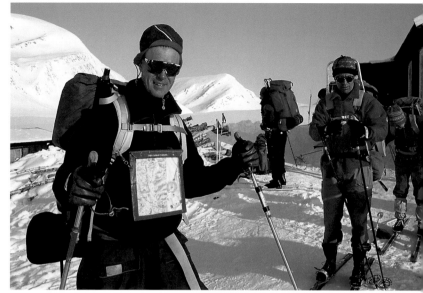

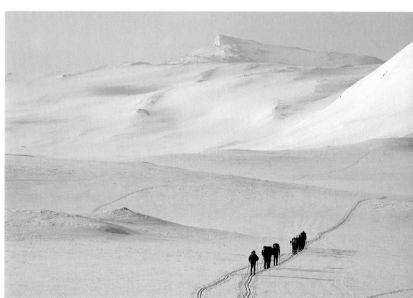

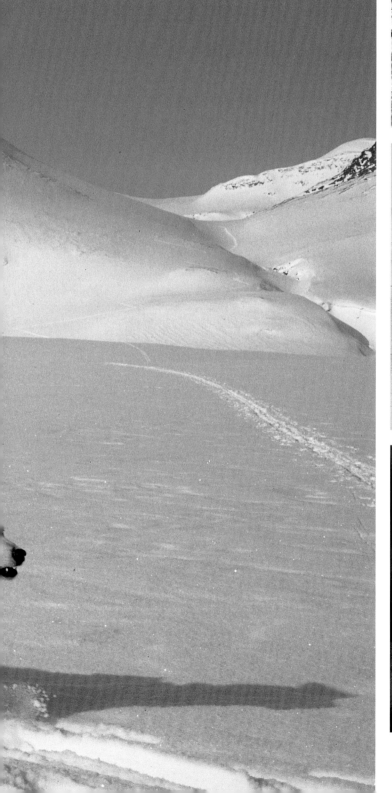

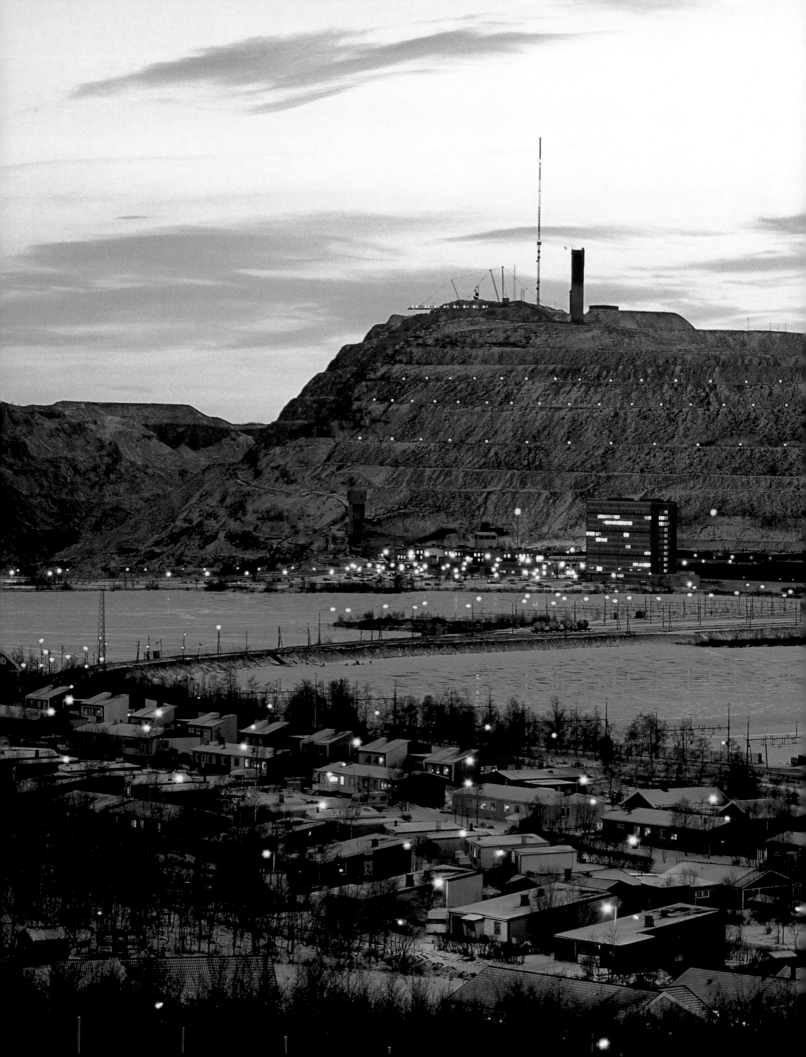

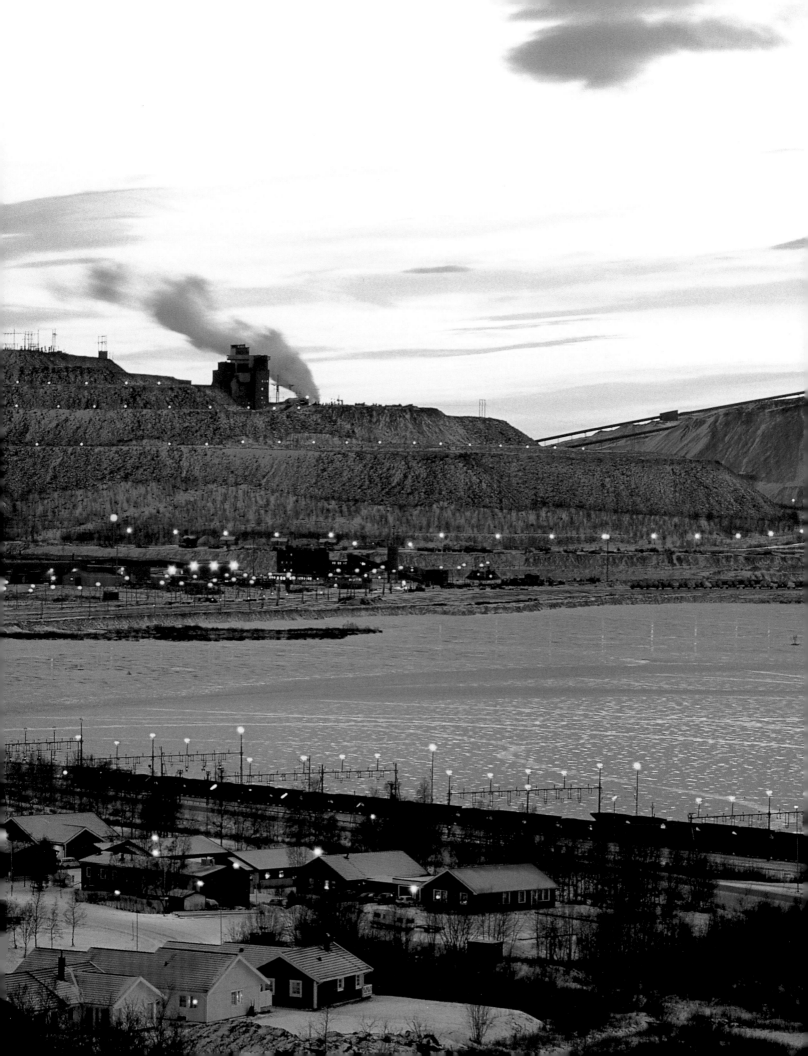

Page 112/113:

At 20,000 square kilometres (7,722 square miles) Kiruna is half the size of The Netherlands and completely dominated by its enormous ore moun

tain Kirunavaara, to which the town owes its existence. The state iron ore society LKAB established in 1890 gradually demolished much of the

mountain above ground, with mining now taking place 300 metres (980 feet) below the surface.

Below:

Lapland is both Europe's last great wilderness and the Land of the Midnight Sun. With its never-ending forest, roaring rivers and crystal lakes mirroring

the mountains of northern Sweden (here the Lappentor range), this part of the globe is an earthly paradise for nature-lovers.

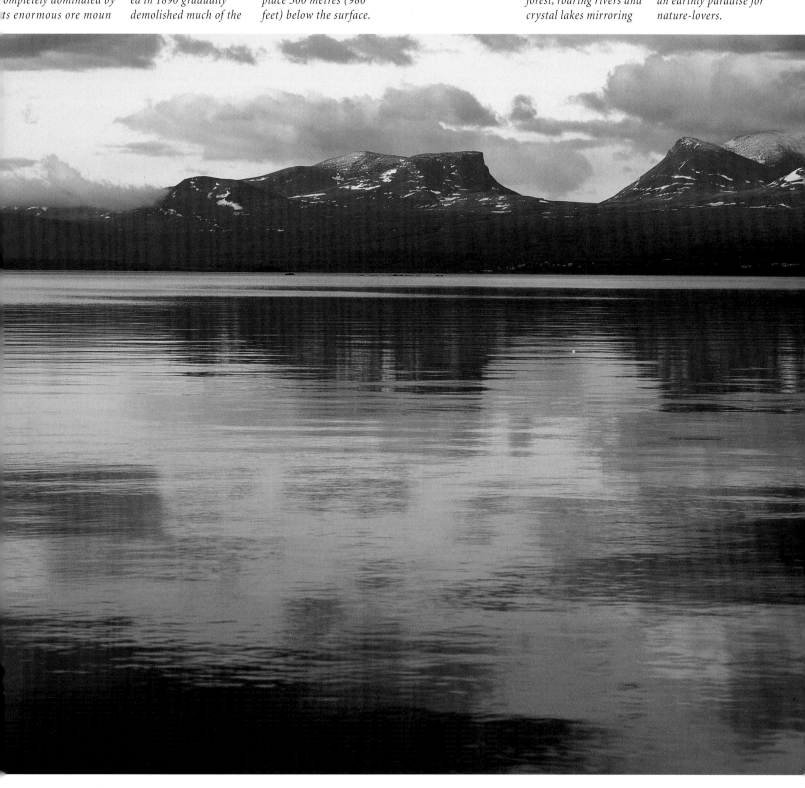

Top left:
Kebnekaise Mountain, at 2,119 metres (6,952 feet) the highest summit in Sweden towering over

the snowy void of Lapland, was where little Nils Holgersson and his wild geese were destined.

Bottom left:
This fishing boat frozen to the banks of the Vittangi in Lapland is grounded for the winter. The upper

reaches of this remote river are gentle, with the lower rapids wild and furious and ideal for river rafting in the summer.

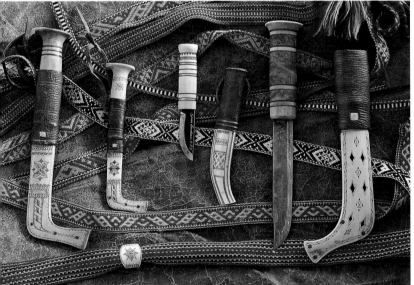

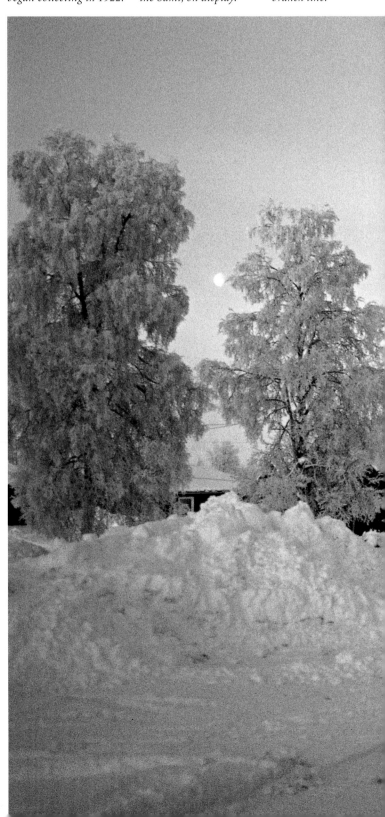

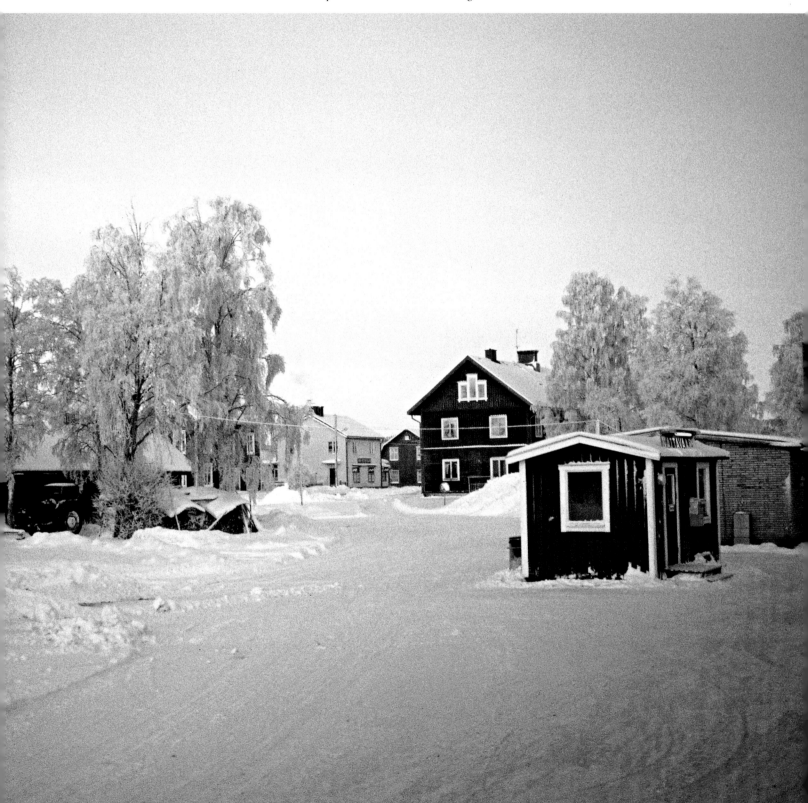

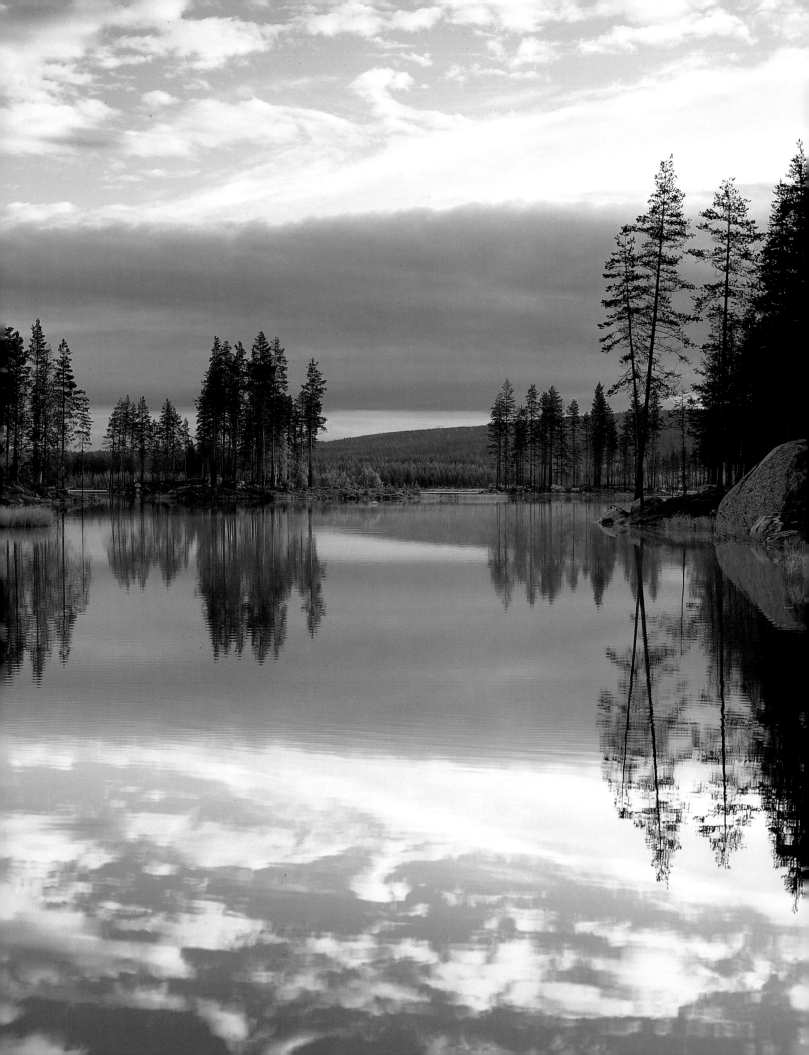

Left:
Fantastic scenery bathed in the eerie light of the north is abundant in Lapland, such as here near Fredrika.

Below:
The hiking trails which traverse northern Sweden, hear near Abisko, often cross boggy ground, made accessible by wooden walkways.

Bottom:
Hunting, and especially elk hunting, which the king participates in each year, is a popular hobby in Sweden. If you don't strike lucky, however, then it's sausages over an open fire for dinner.

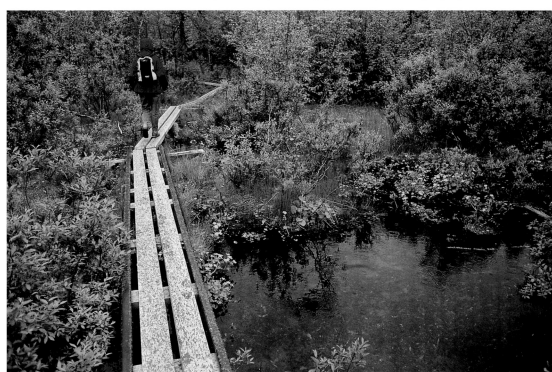

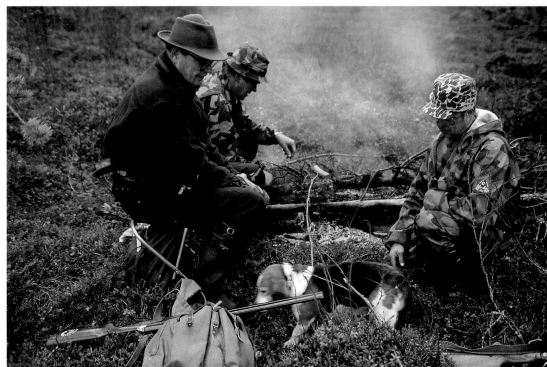

Page 120/121:
Lapland's vast icy wastes
seen from the air:
the Rapaälven Delta.

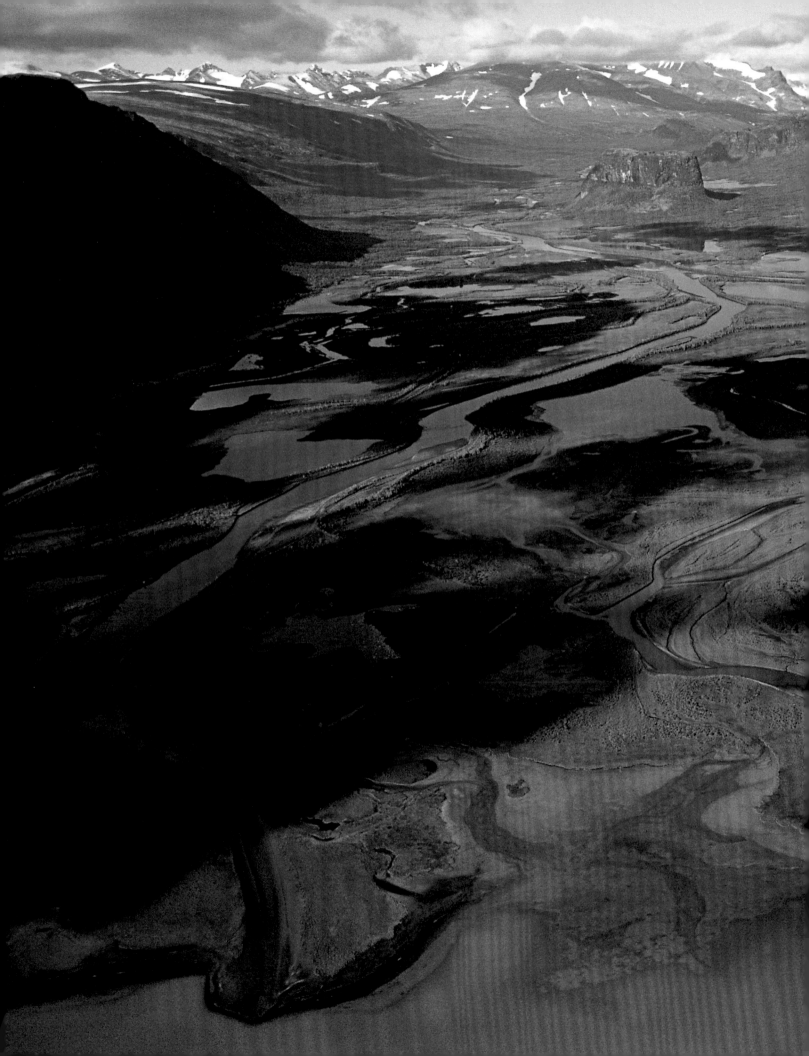

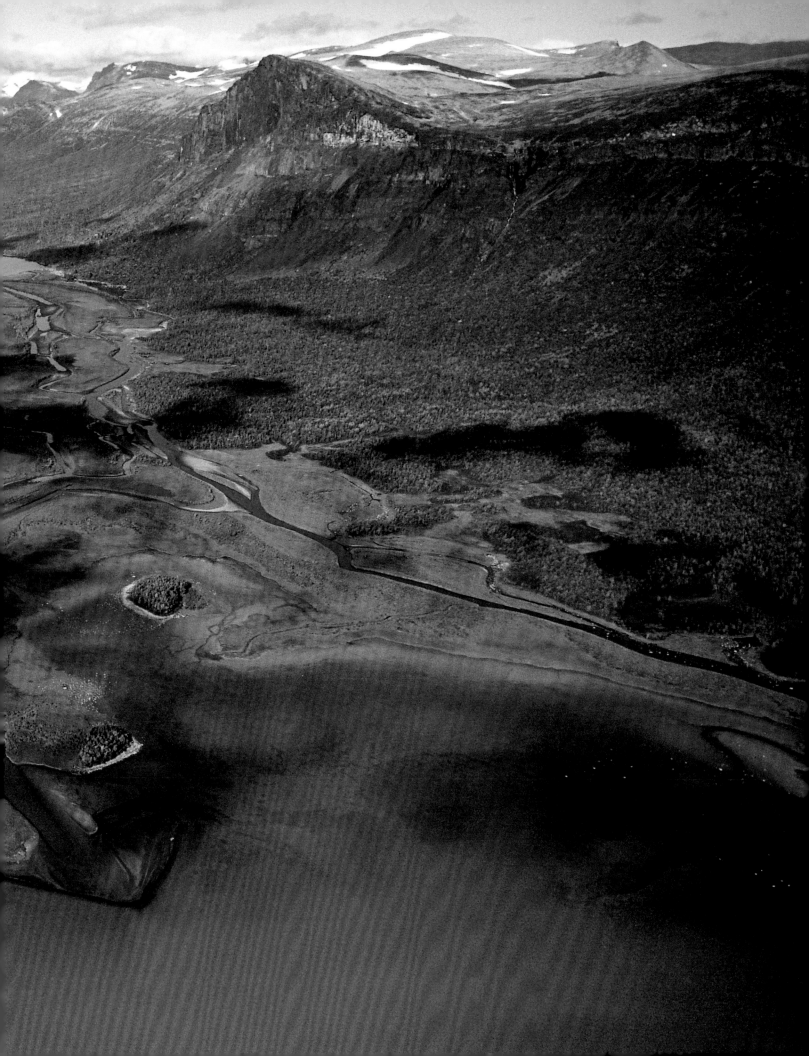

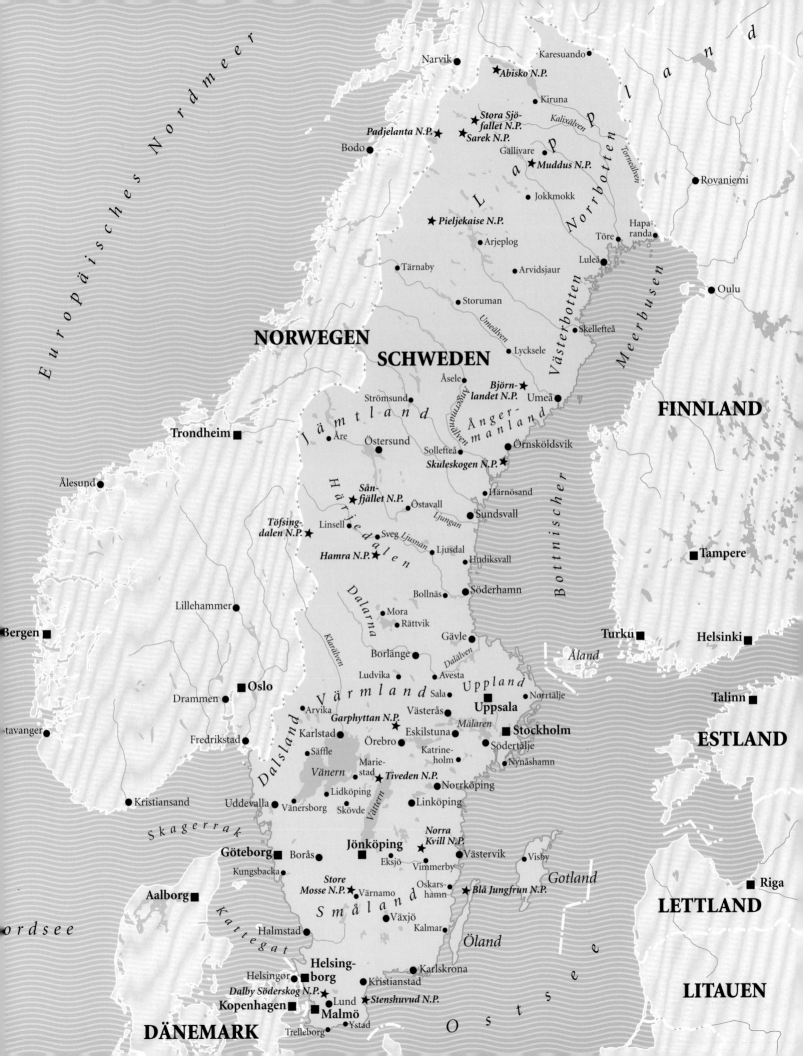

The name Ohlsson, here affixed to a door in Karlskrona, is very common in Sweden. Lots of names end in –«son«, which, as the suffix suggest, means »the son of ...«.

Credits

Design
hoyerdesign grafik gmbh, Freiburg

Map
Fischer Kartografie, Fürstenfeldbruck

Translation
Ruth Chitty, Schweppenhausen

Printed in Germany
Repro by Artilitho, Trento, Italy
Printed by Konkordia GmbH, Bühl
Bound by Josef Spinner Großbuchbinderei GmbH, Ottersweier
© 2002 Verlagshaus Würzburg GmbH & Co. KG
© Photos: Max Galli, St. Moritz, Switzerland

ISBN 3-8003-1588-2

Stürtz